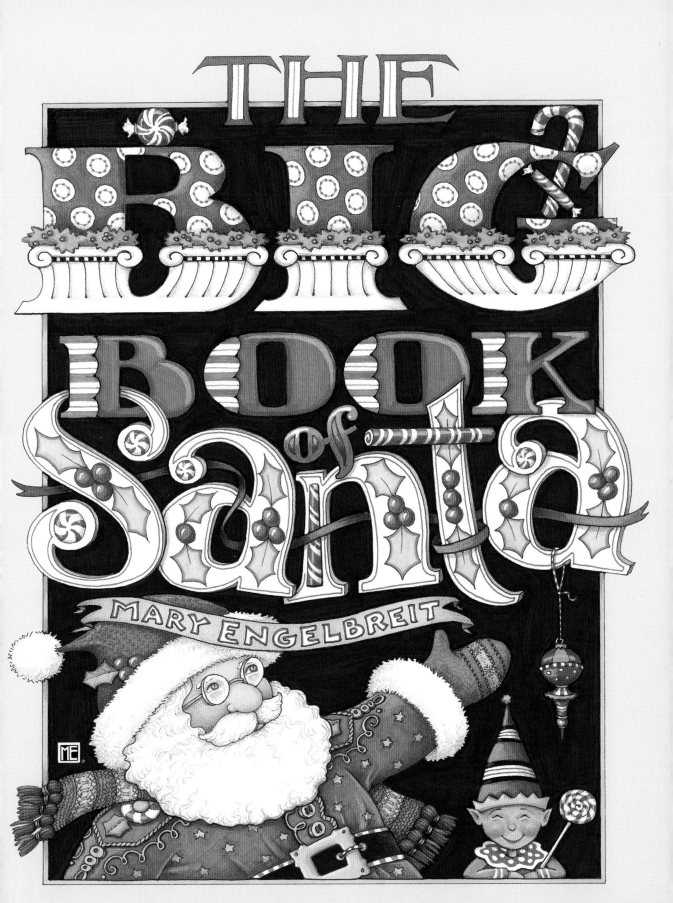

THE BIG BOOK OF SANTA

MARY ENGELBREIT

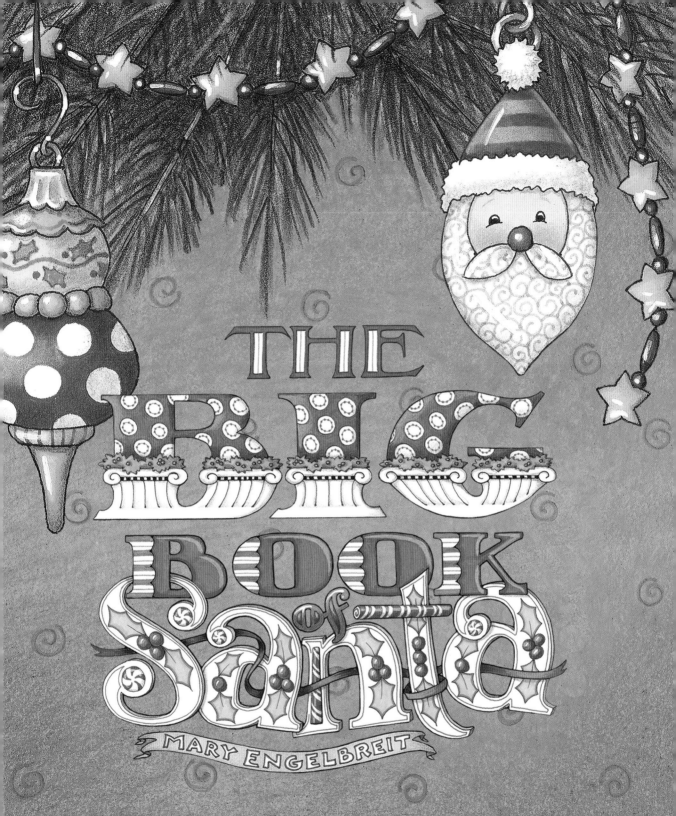

THE BIG BOOK OF SANTA

MARY ENGELBREIT

Andrews McMeel
Publishing®

a division of Andrews McMeel Universal

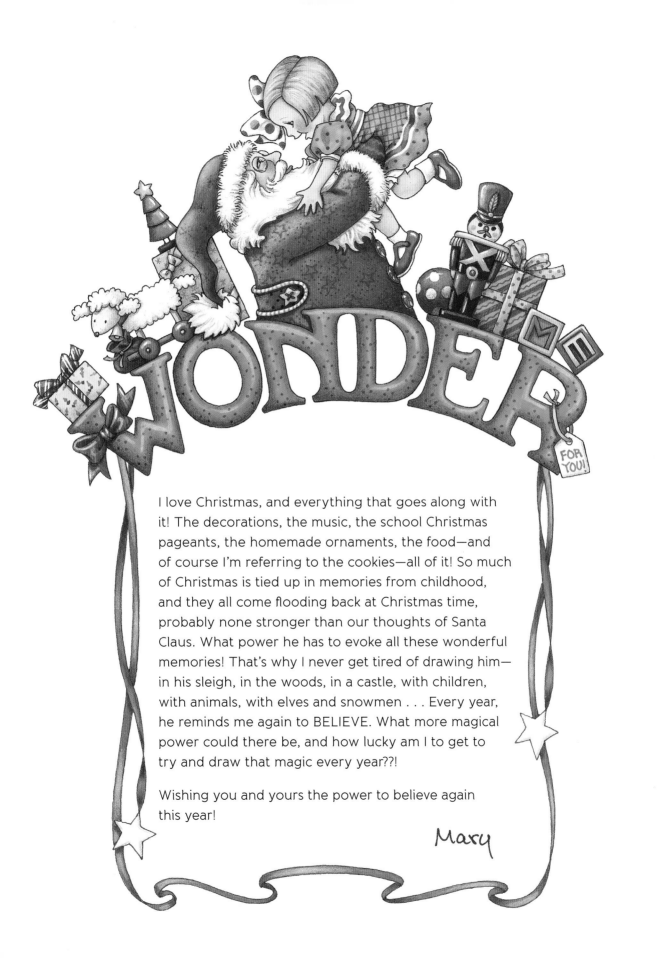

I love Christmas, and everything that goes along with it! The decorations, the music, the school Christmas pageants, the homemade ornaments, the food—and of course I'm referring to the cookies—all of it! So much of Christmas is tied up in memories from childhood, and they all come flooding back at Christmas time, probably none stronger than our thoughts of Santa Claus. What power he has to evoke all these wonderful memories! That's why I never get tired of drawing him— in his sleigh, in the woods, in a castle, with children, with animals, with elves and snowmen . . . Every year, he reminds me again to BELIEVE. What more magical power could there be, and how lucky am I to get to try and draw that magic every year??!

Wishing you and yours the power to believe again this year!

Mary

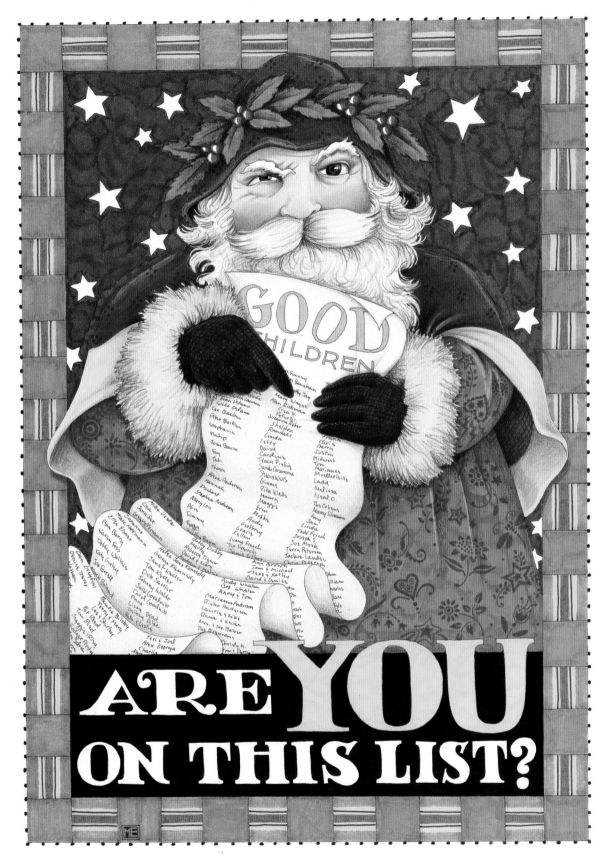

The Good List

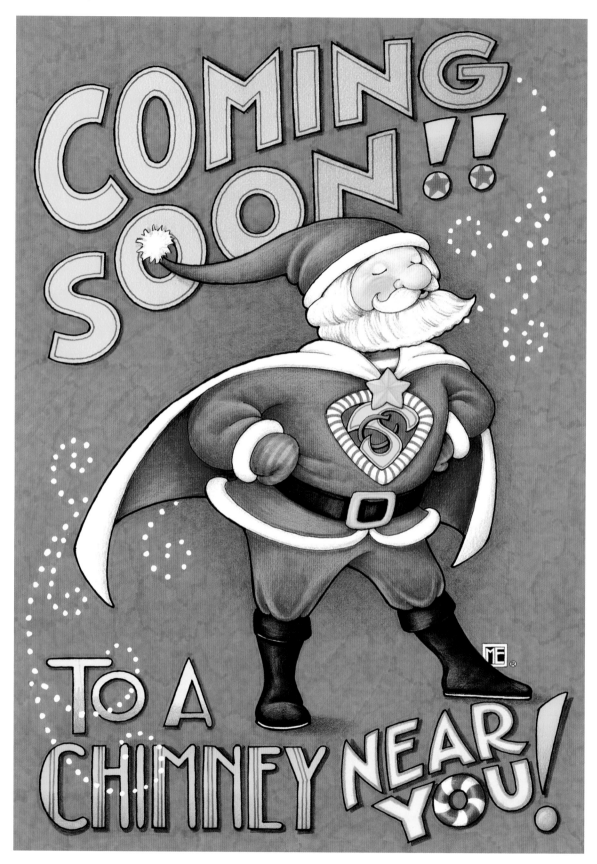

HEIGH HO, the HOLLY

ISN'T CHRISTMAS JOLLY?

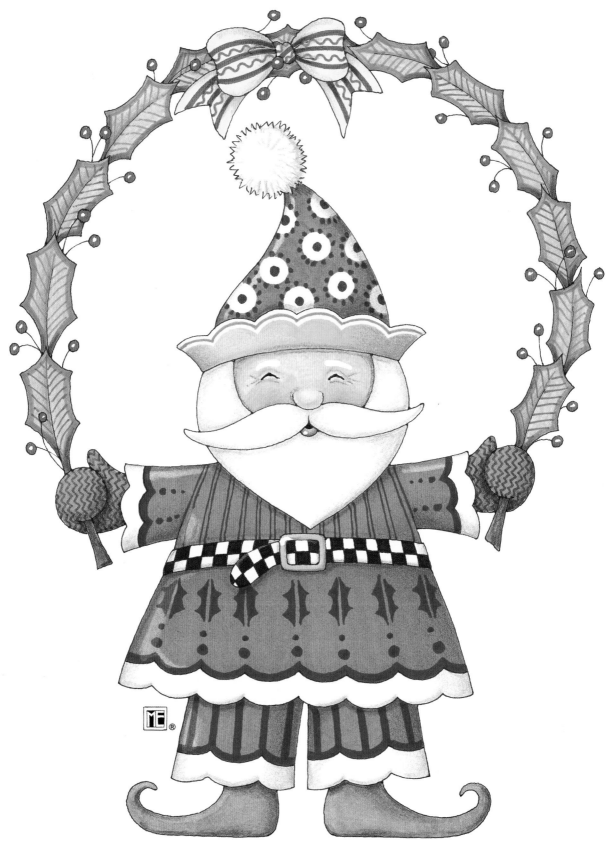

Holly Wreath Santa

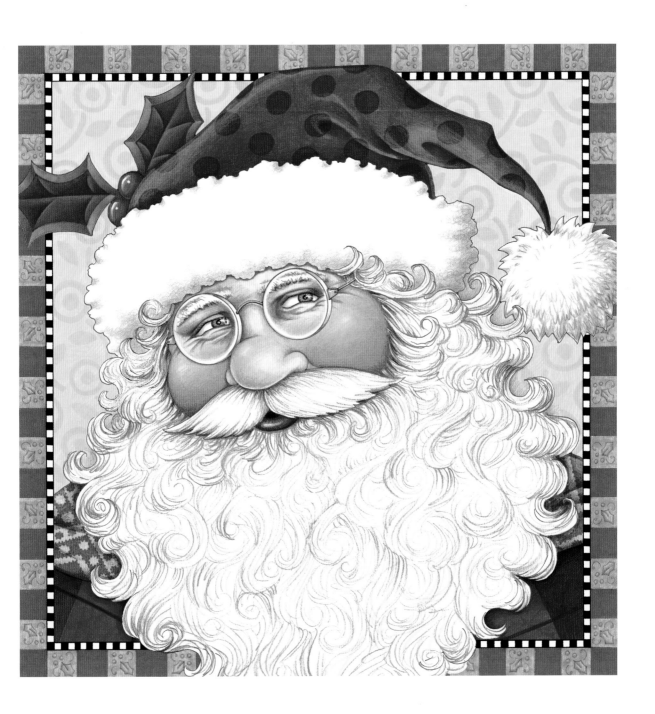

Big Santa Face

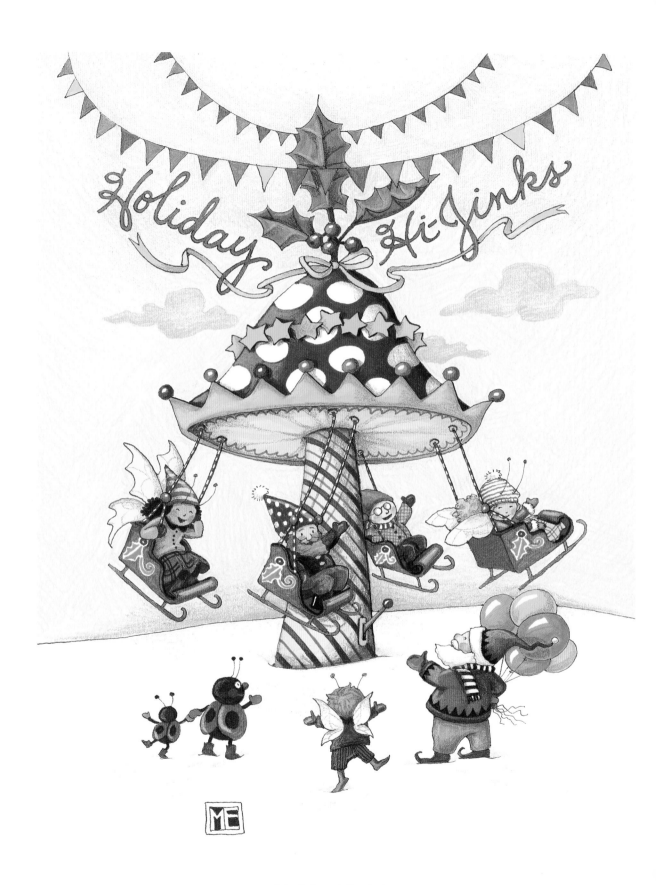

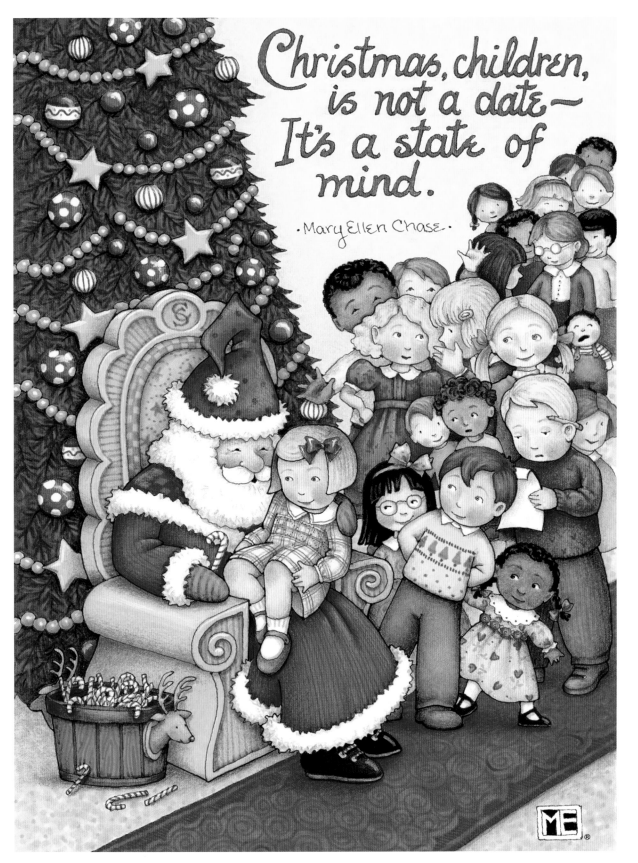

Christmas, children, is not a date—
It's a state of mind.

·Mary Ellen Chase·

Christmas State of Mind

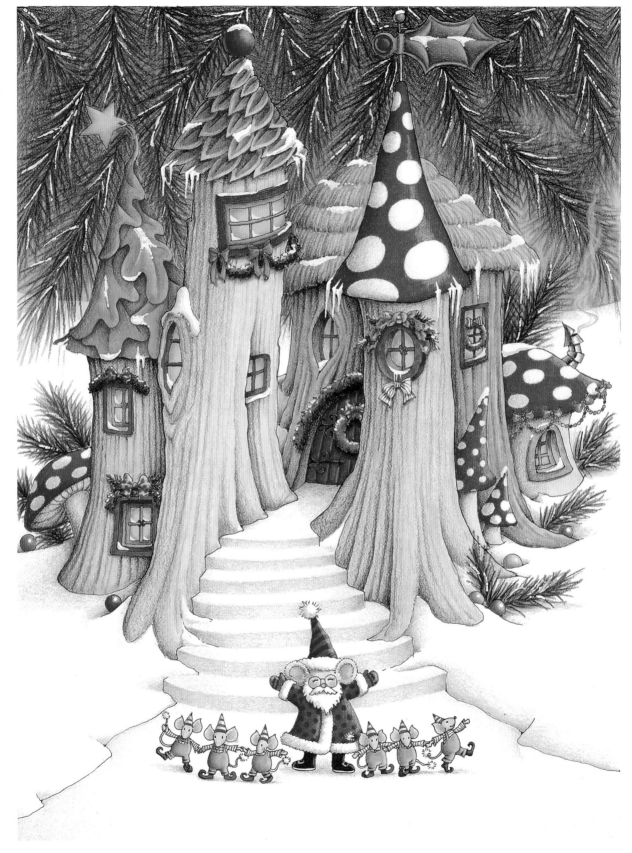

North Pole in Mouseland

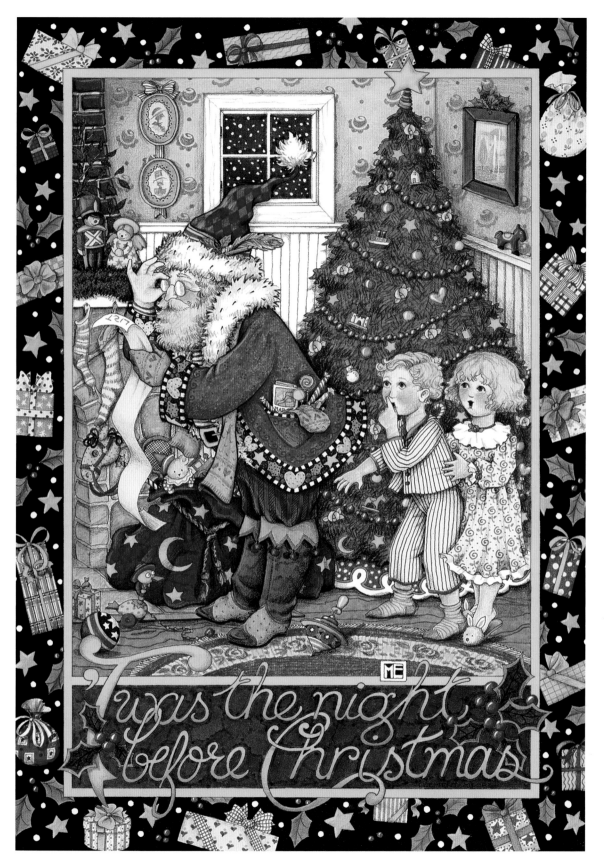

'Twas the Night Before Christmas

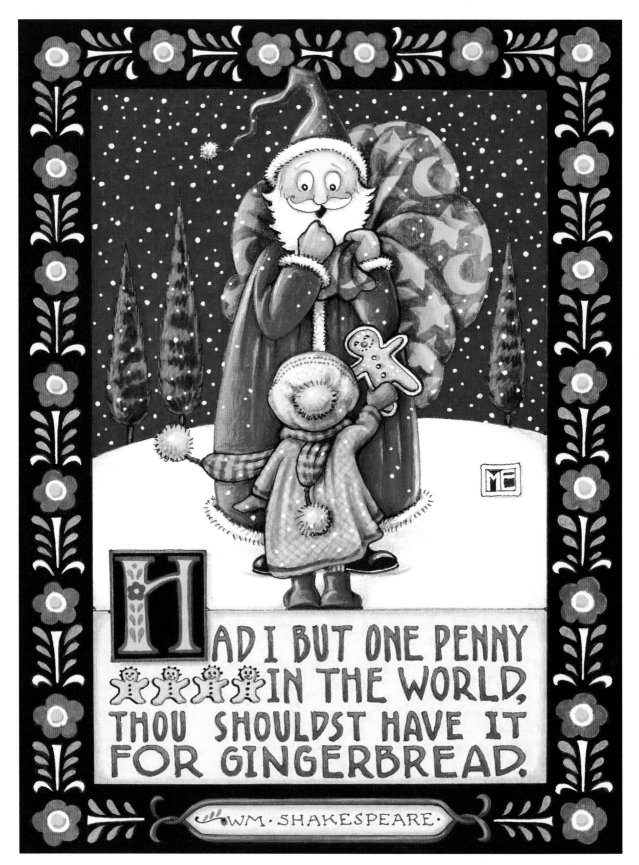

HAD I BUT ONE PENNY IN THE WORLD, THOU SHOULDST HAVE IT FOR GINGERBREAD.

WM · SHAKESPEARE

Penny Gingerbread

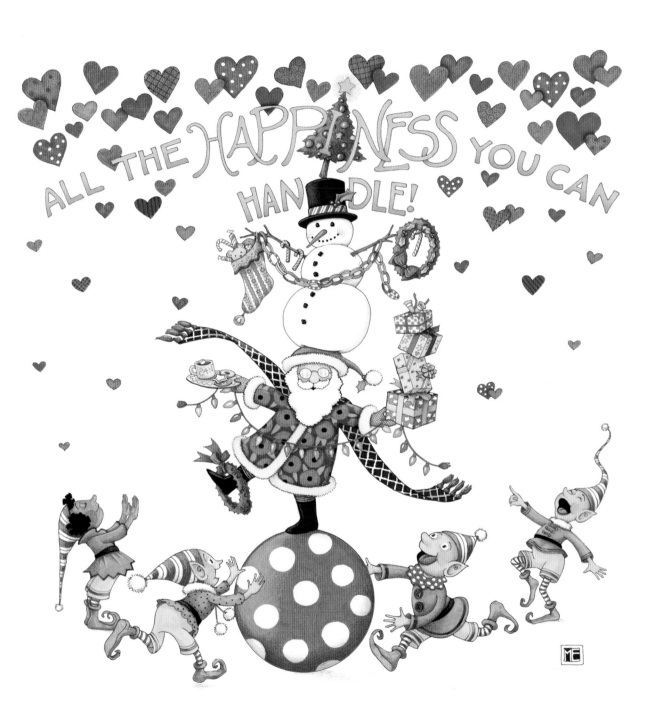

Christmas Circus

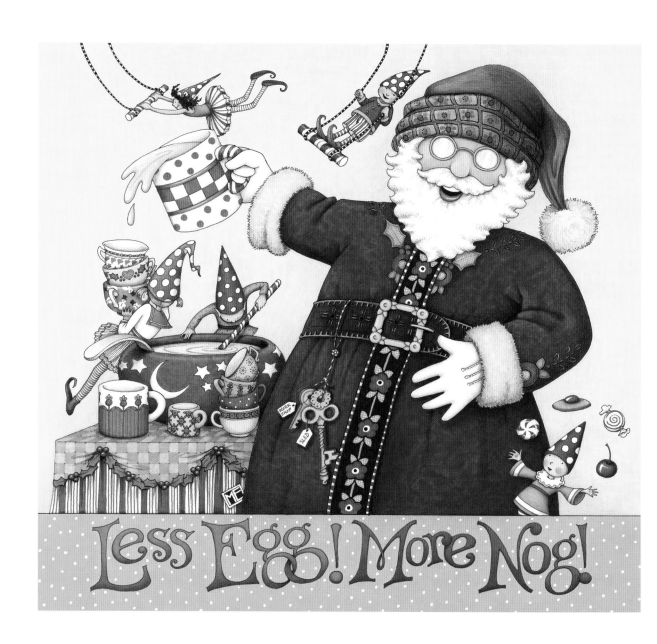

Less Egg! More Nog!

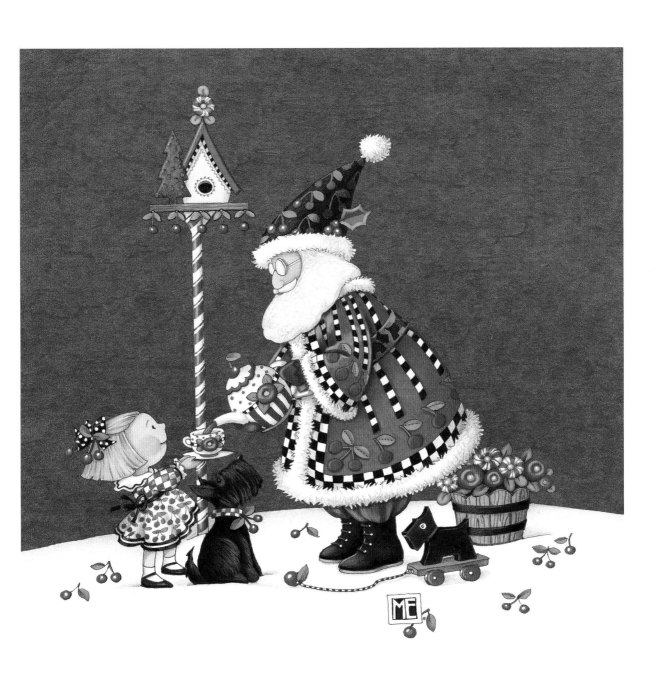

Cherry Christmas

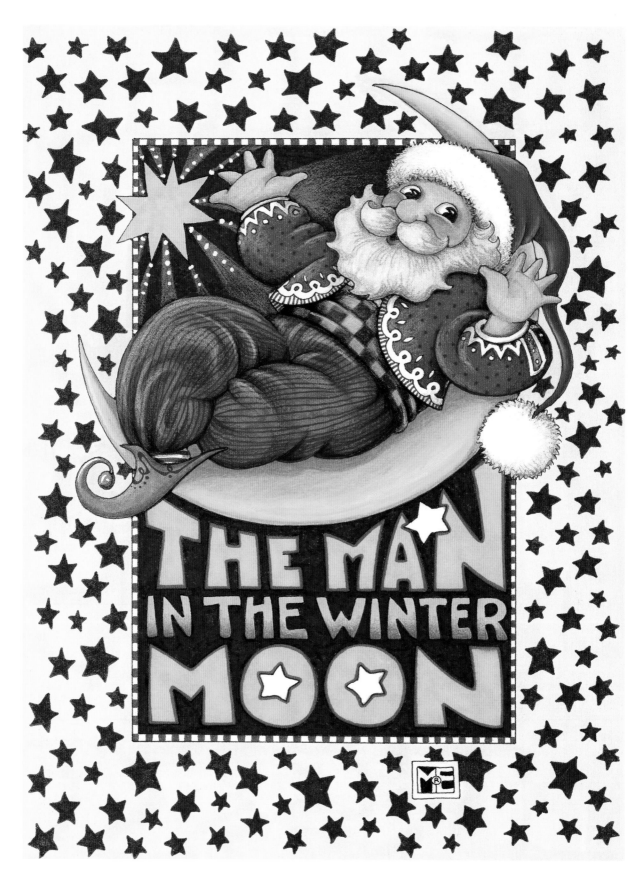

Man in the Winter Moon

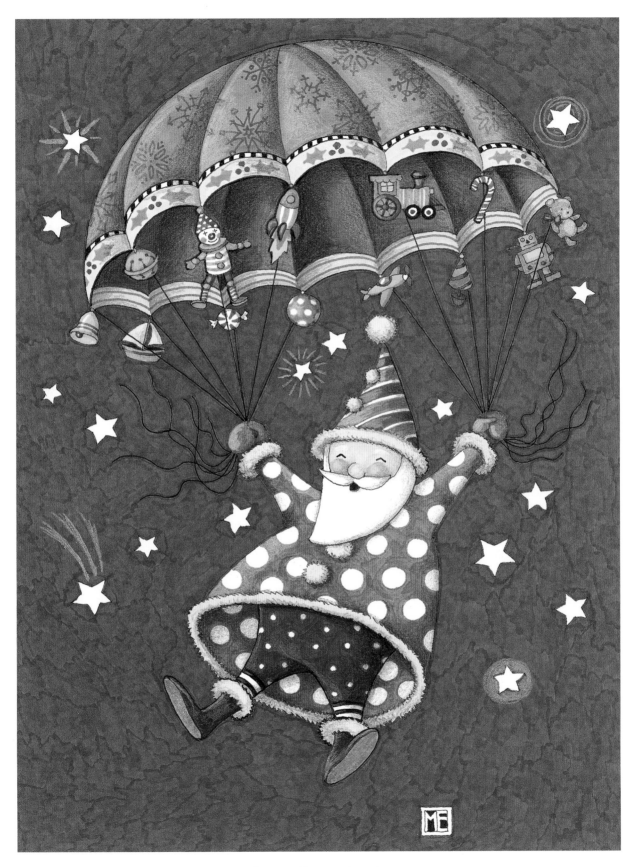

Santa Dropping In

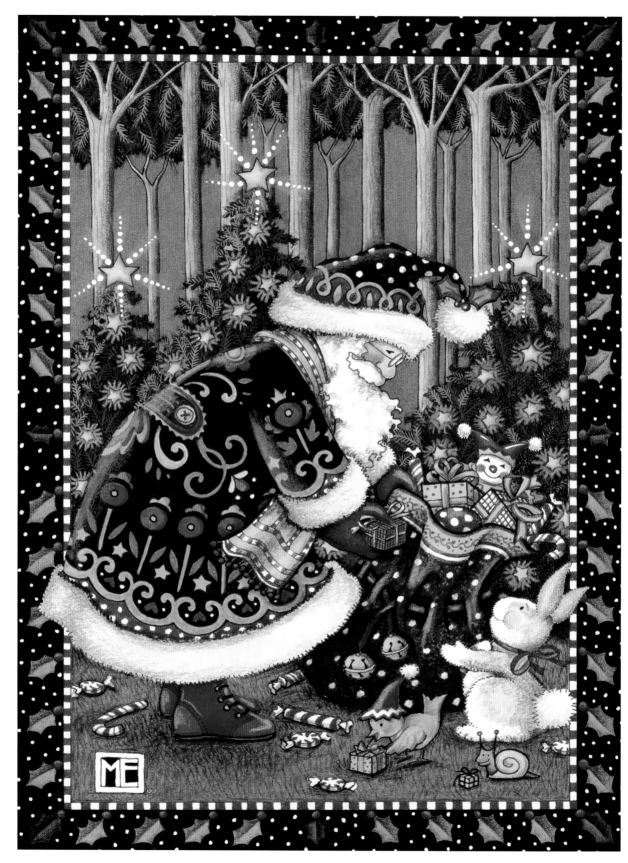

The Animals' Christmas

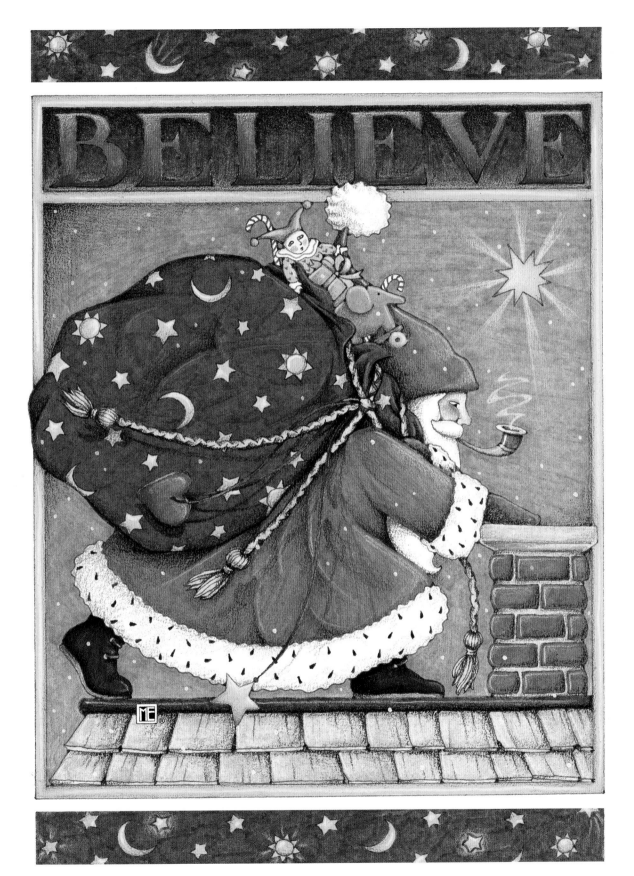

Believe

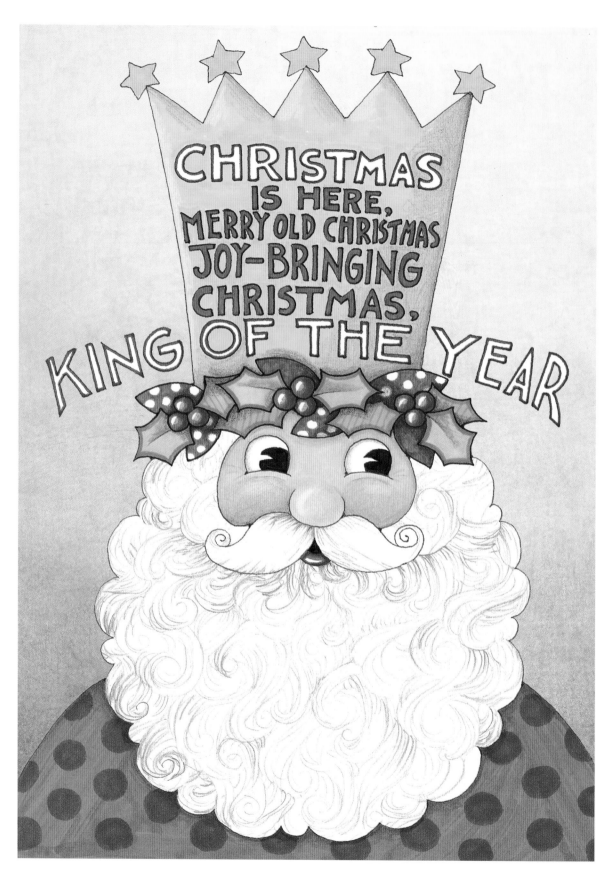

King of the Year

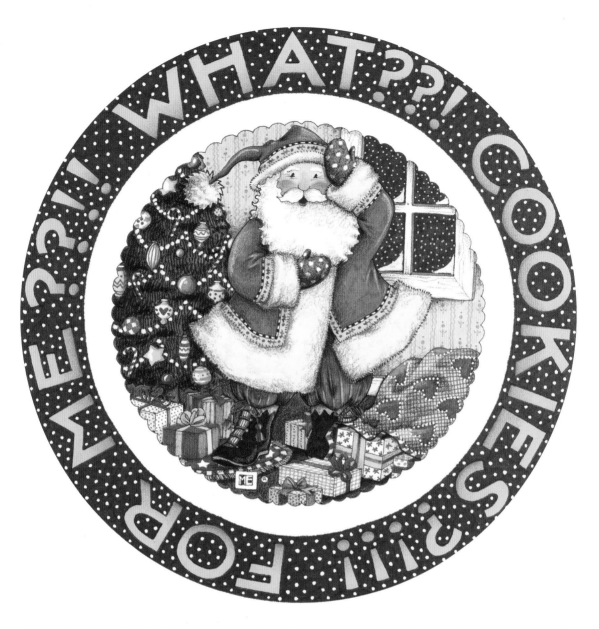

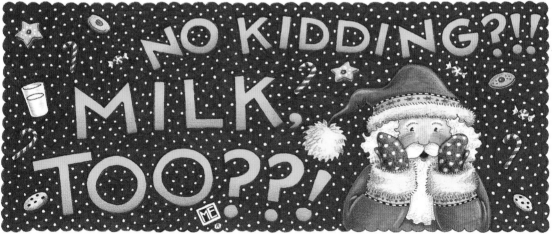

Cookies for Me? No Kidding?!

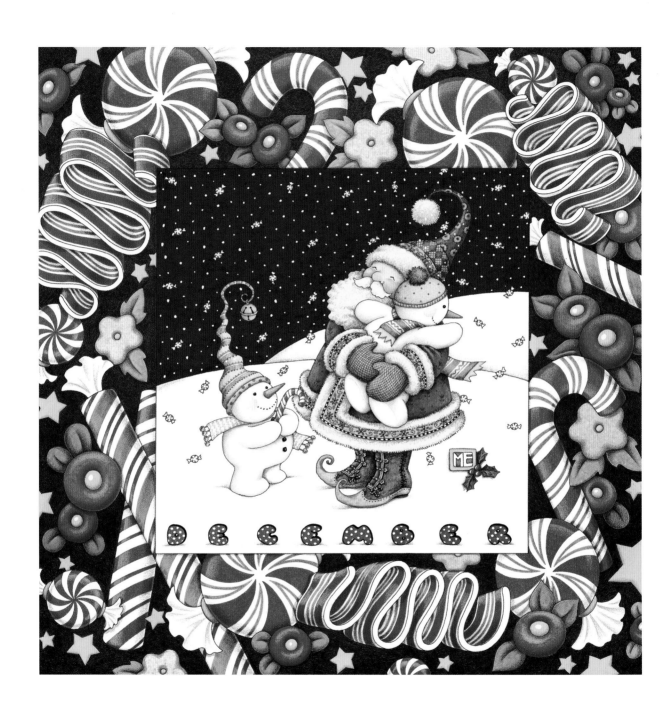

December Hugs

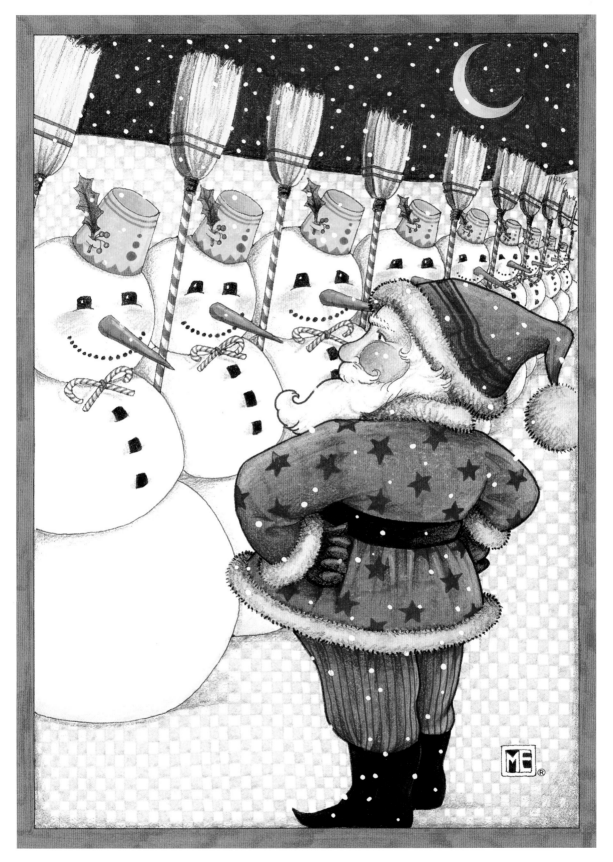

Snowmen Soldiers

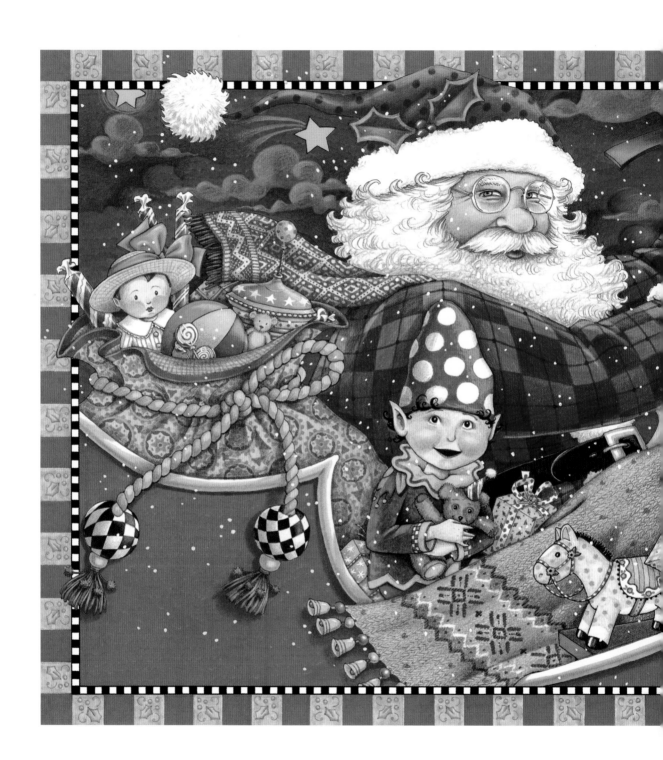

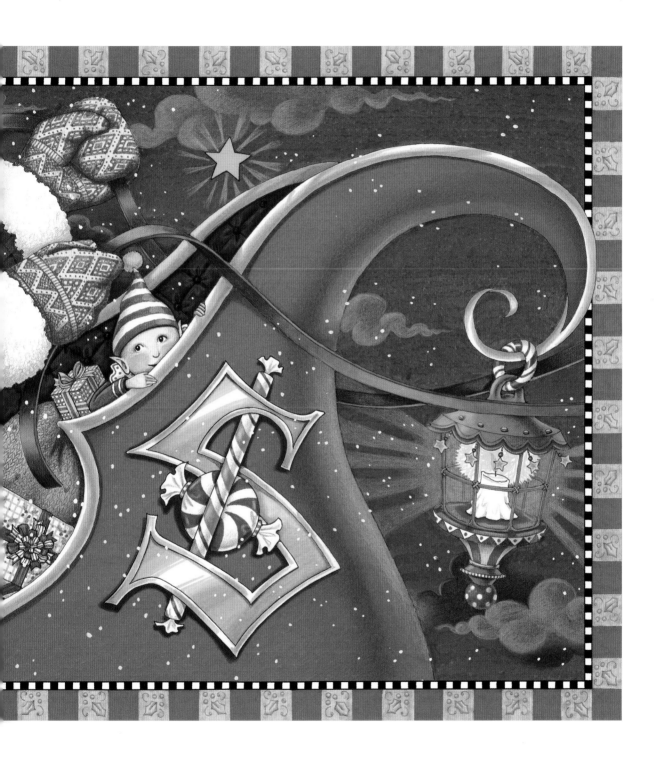

Santa's Sleigh

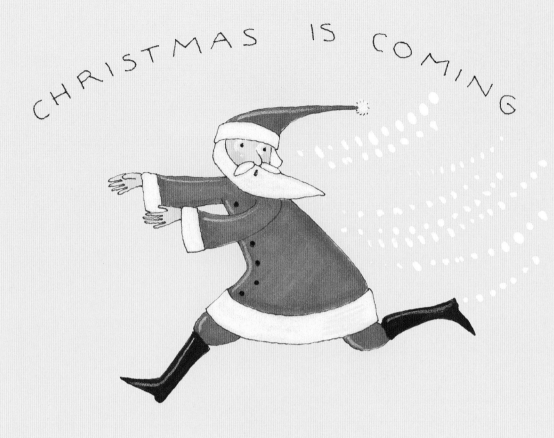

CHRISTMAS IS COMING

RUN AWAY! RUN AWAY!

Run Away Christmas

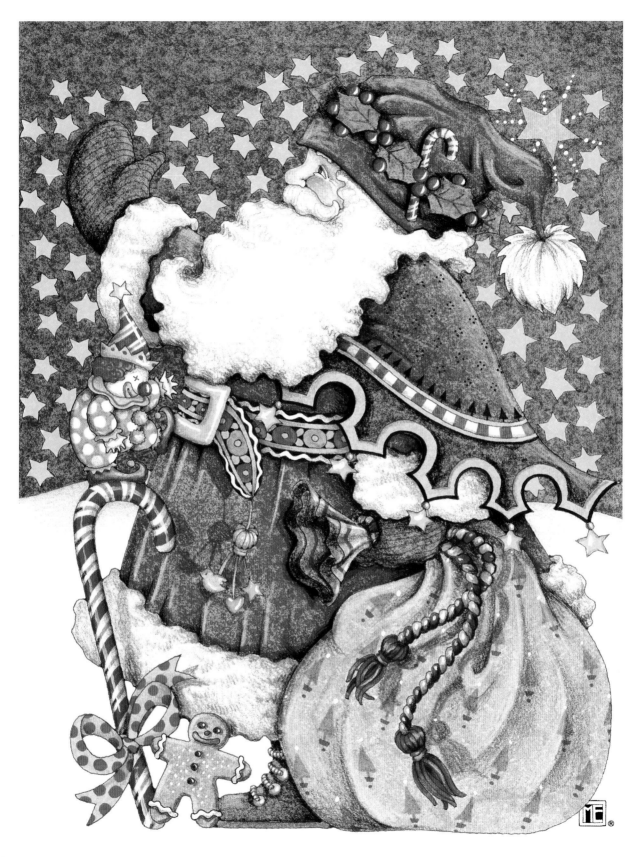

Santa Says Hello

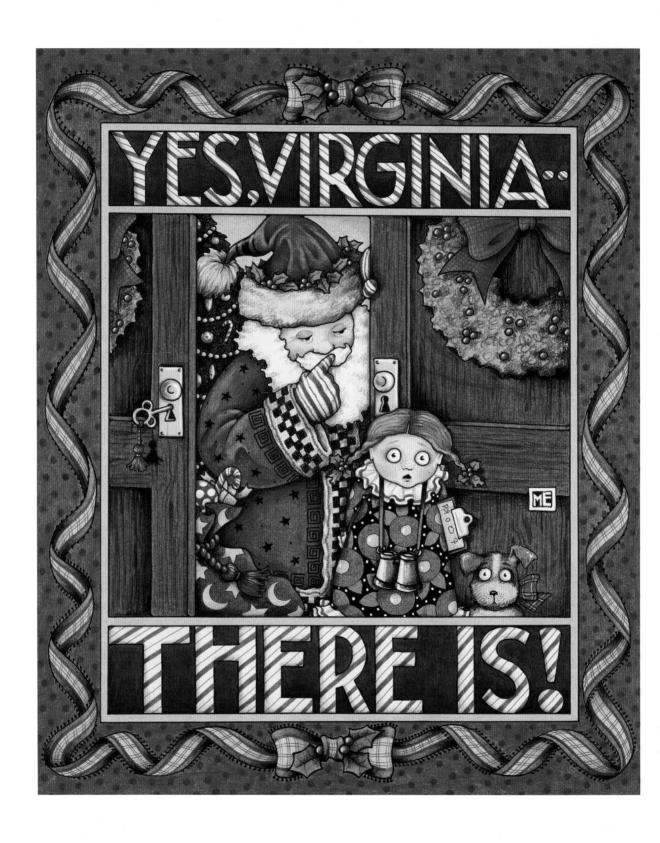

Yes, Virginia...There Is

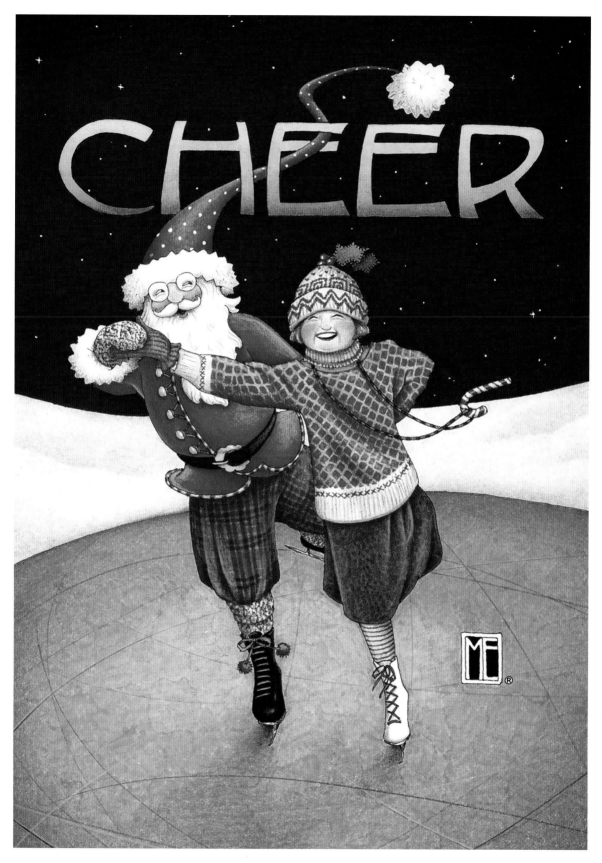

Cheer

HO HO HO .

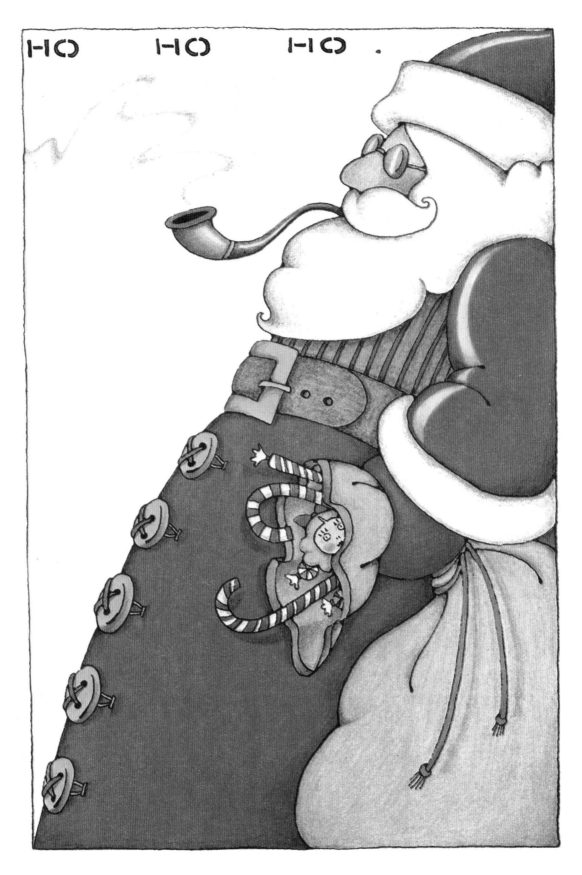

Fat Santa

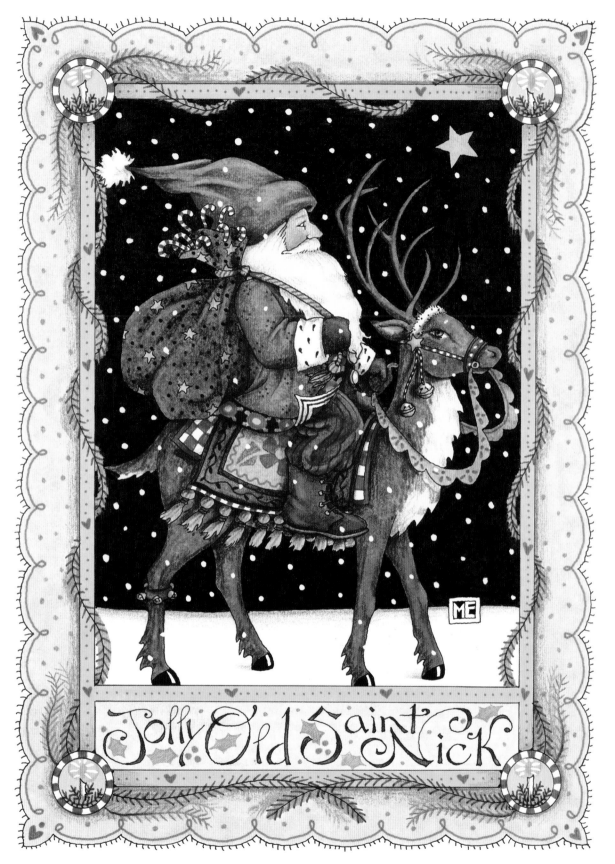

Jolly Old Saint Nick

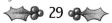

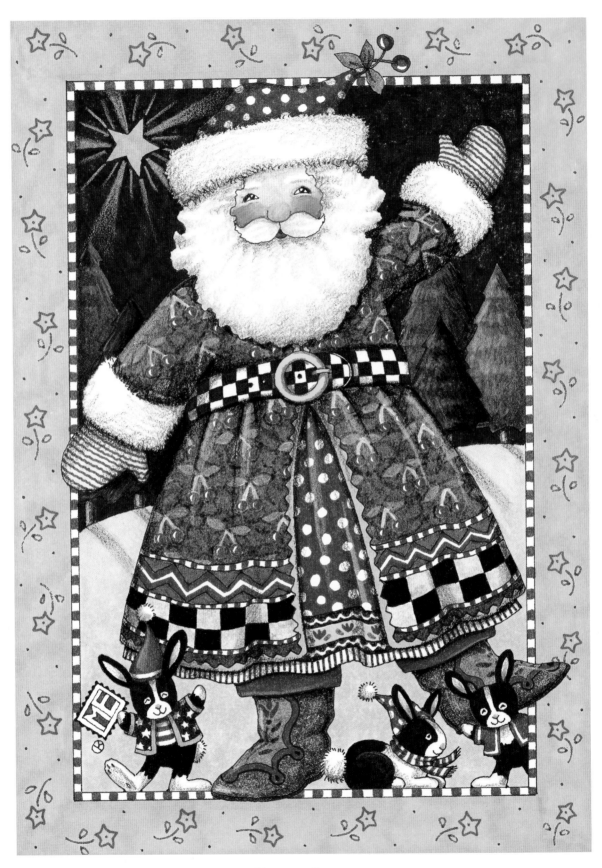

Cherry Santa

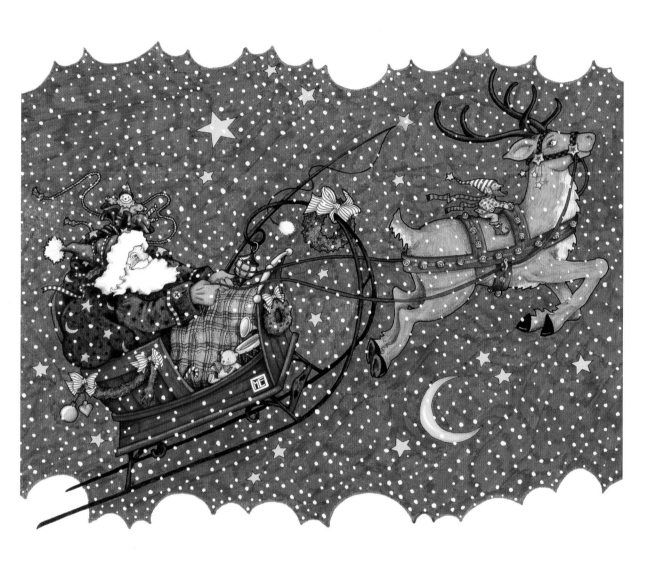

Santa's Sleigh Ride

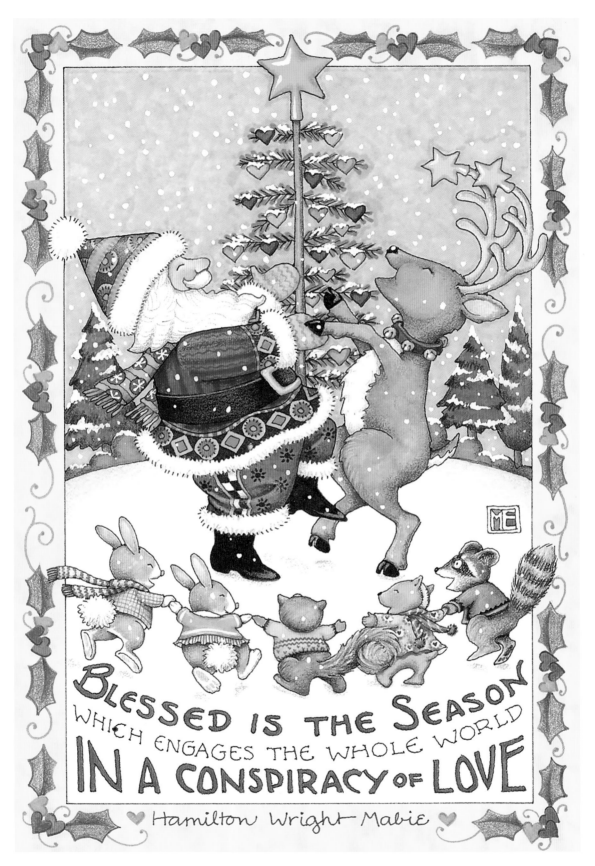

BLESSED IS THE SEASON
WHICH ENGAGES THE WHOLE WORLD
IN A CONSPIRACY OF LOVE

♥ Hamilton Wright Mabie ♥

Ring Around the Santa

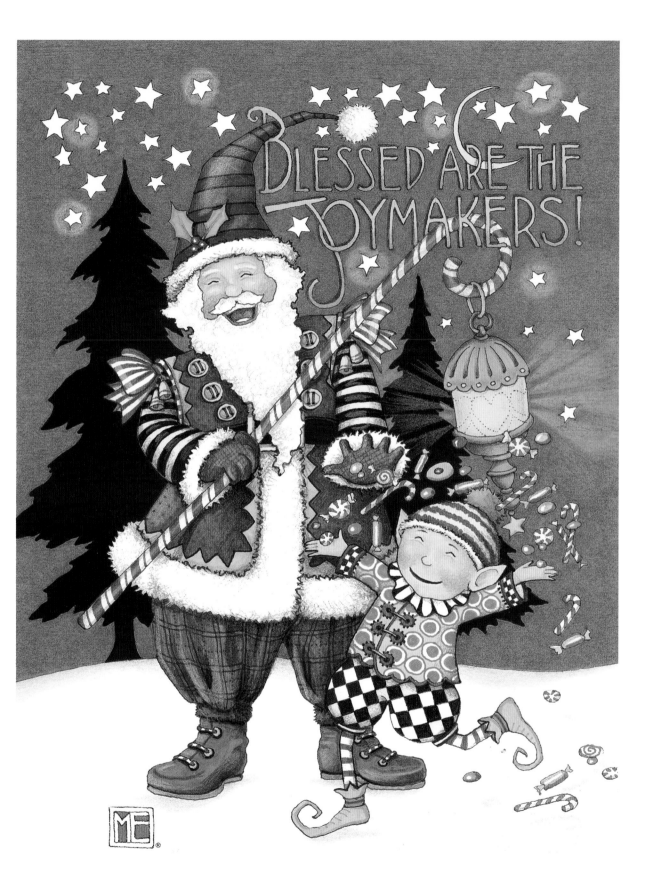

The Joymakers

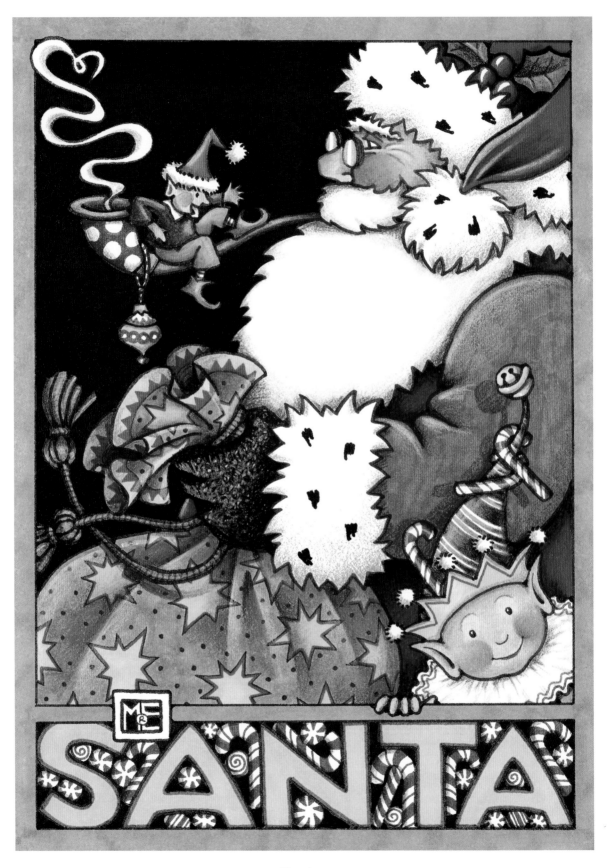

Santa

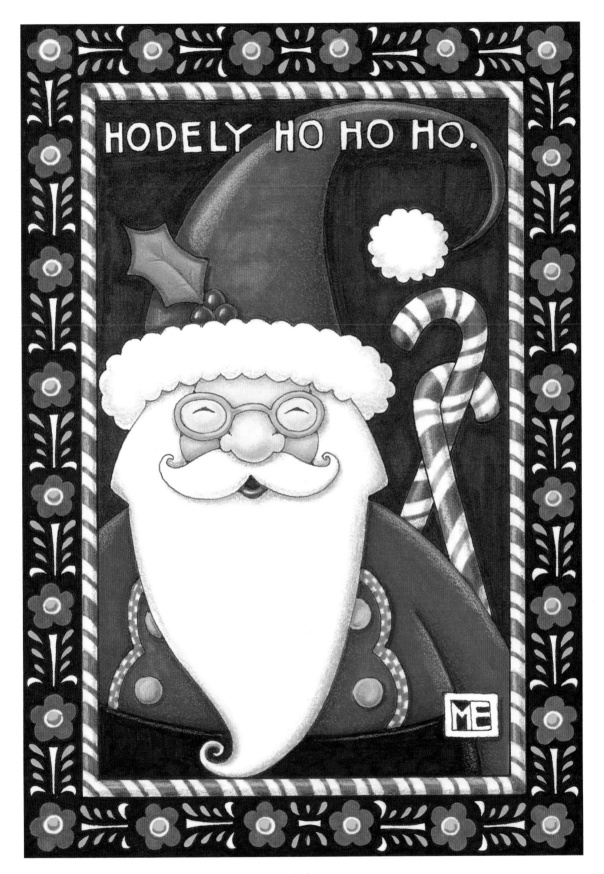

Hodely Ho

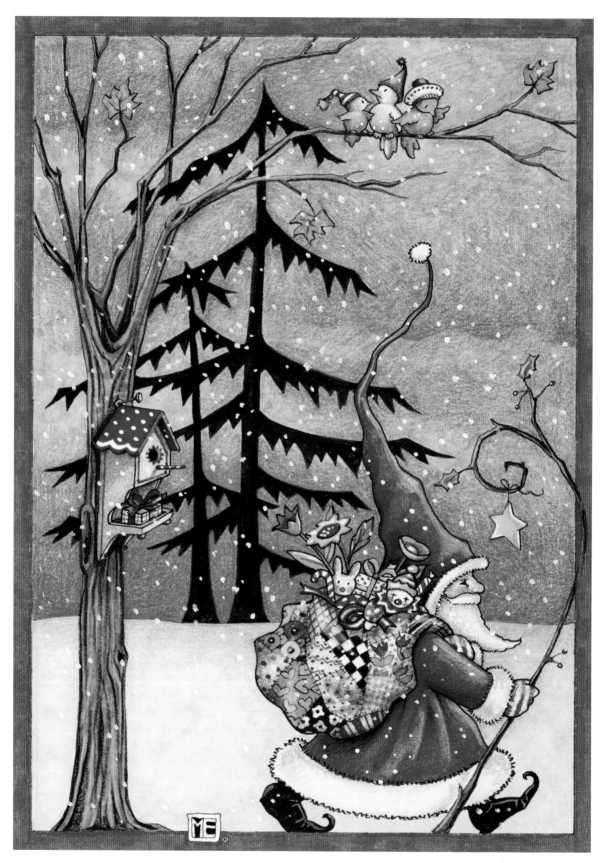

Santa Marches On

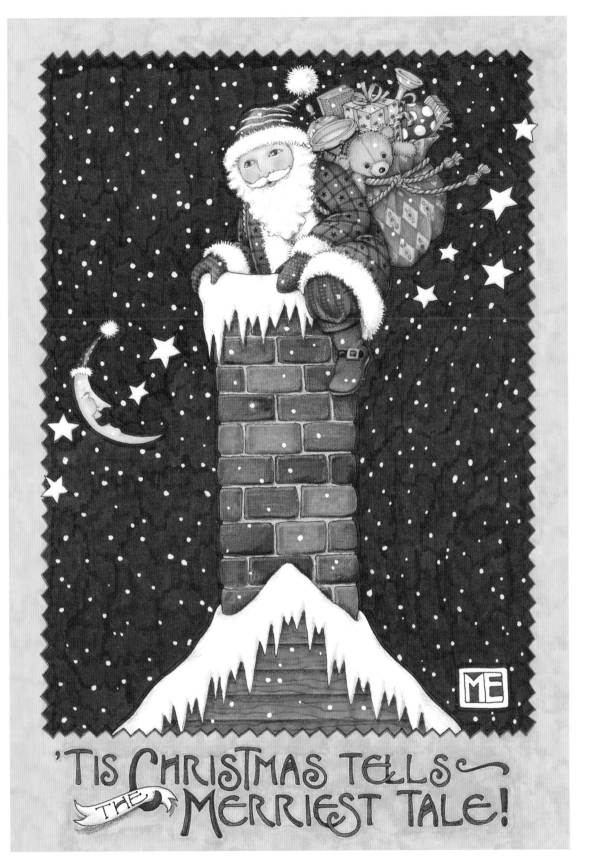

'TIS CHRISTMAS TELLS THE MERRIEST TALE!

Santa, What a Bag

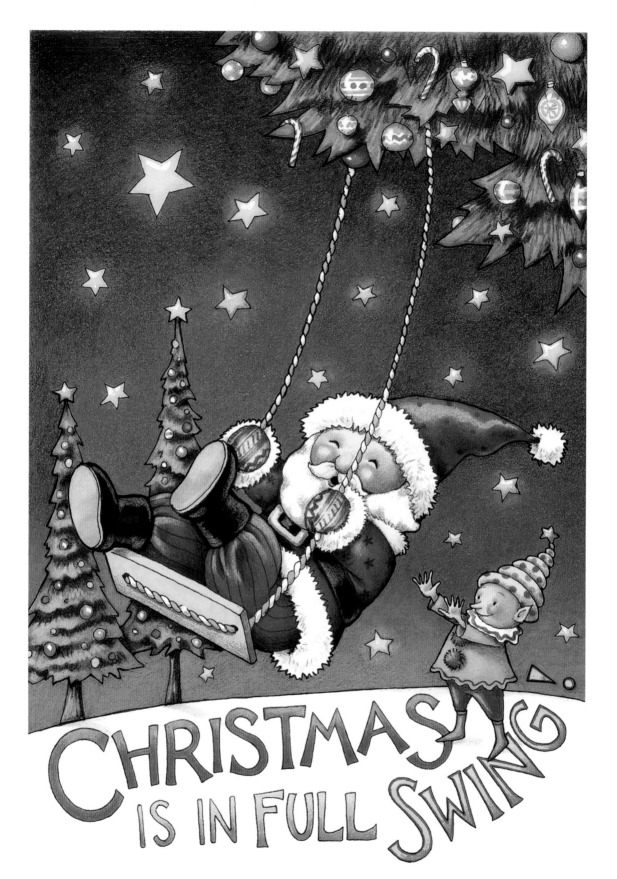

Christmas Is in Full Swing

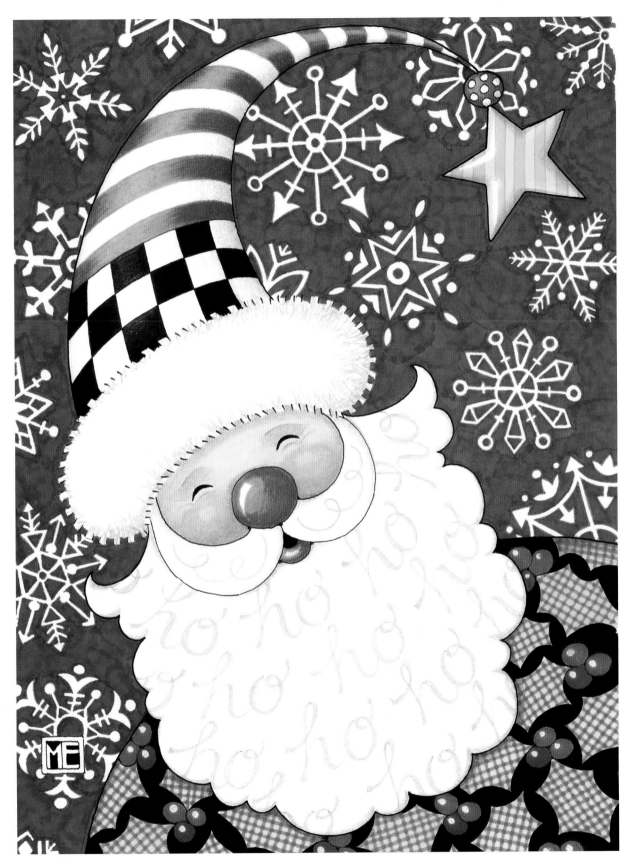

Santa Snowflake

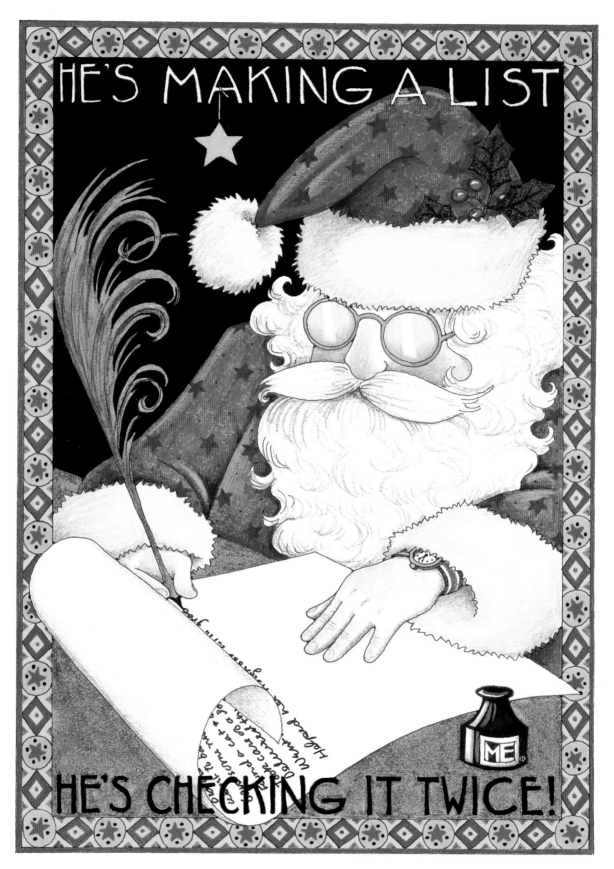

He's Making a List

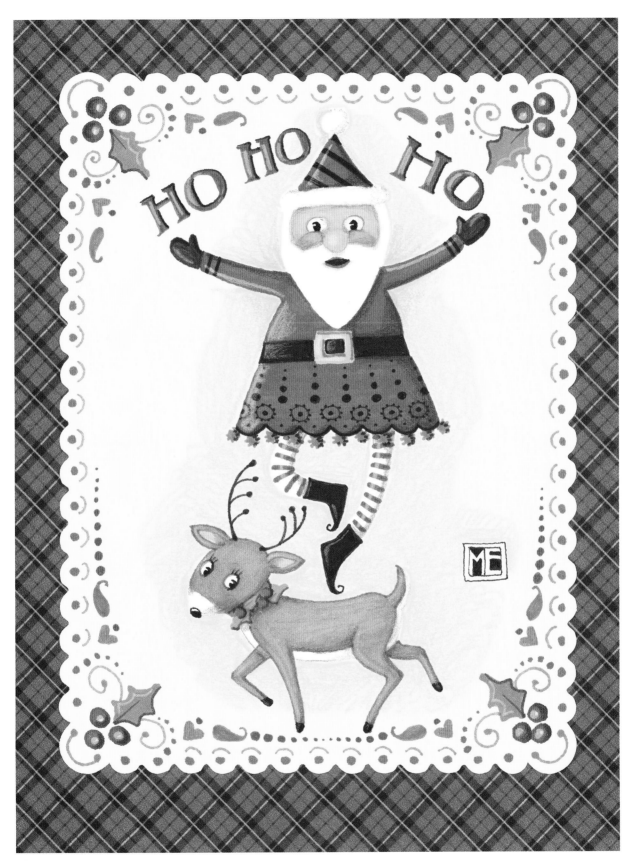

Ho Ho Ho Santa

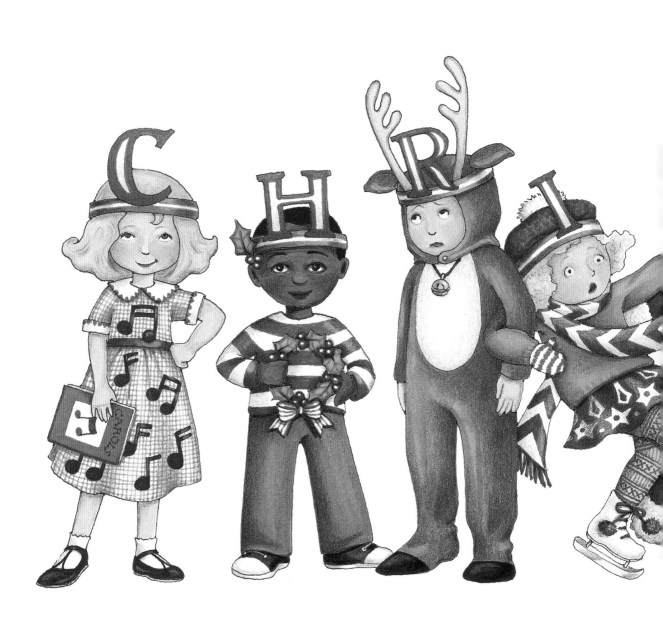

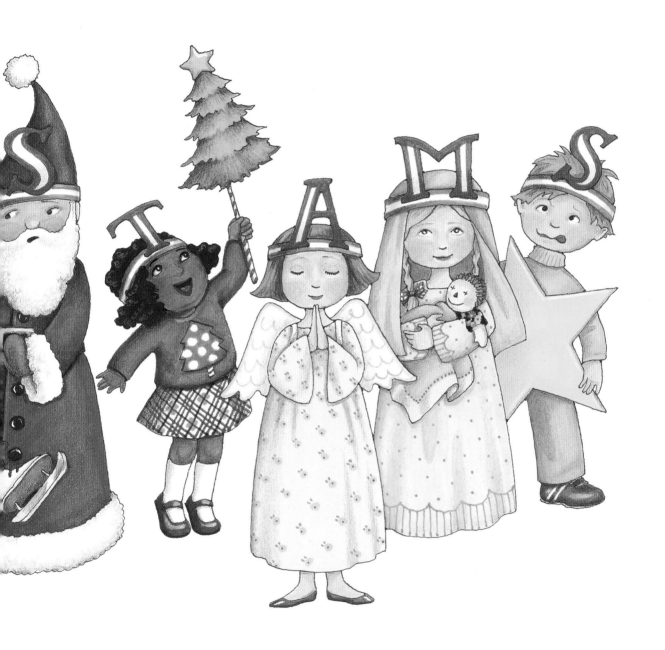

Christmas Pageant Fun

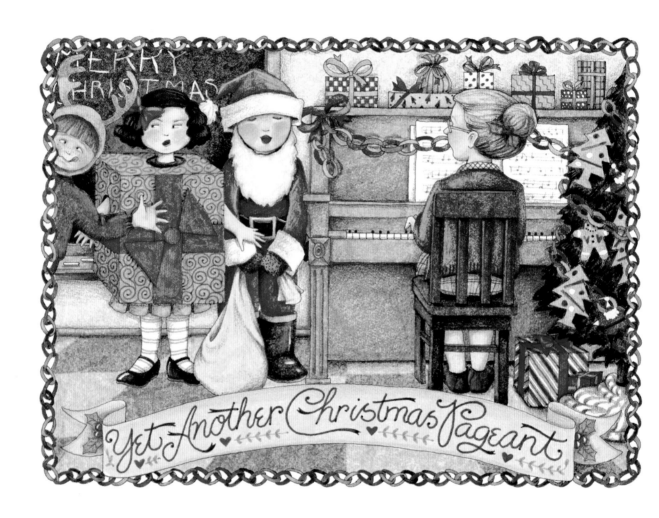

Yet Another Christmas Pageant

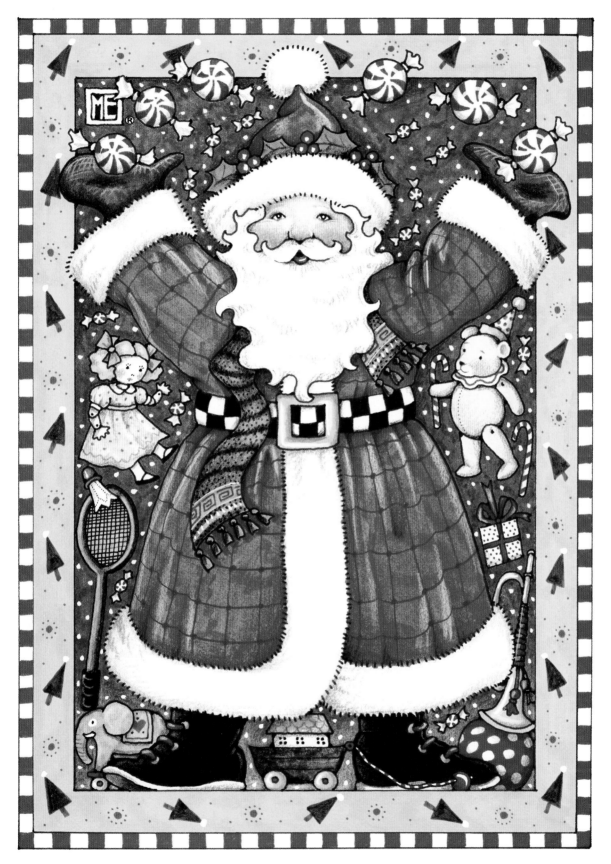

Candy Santa

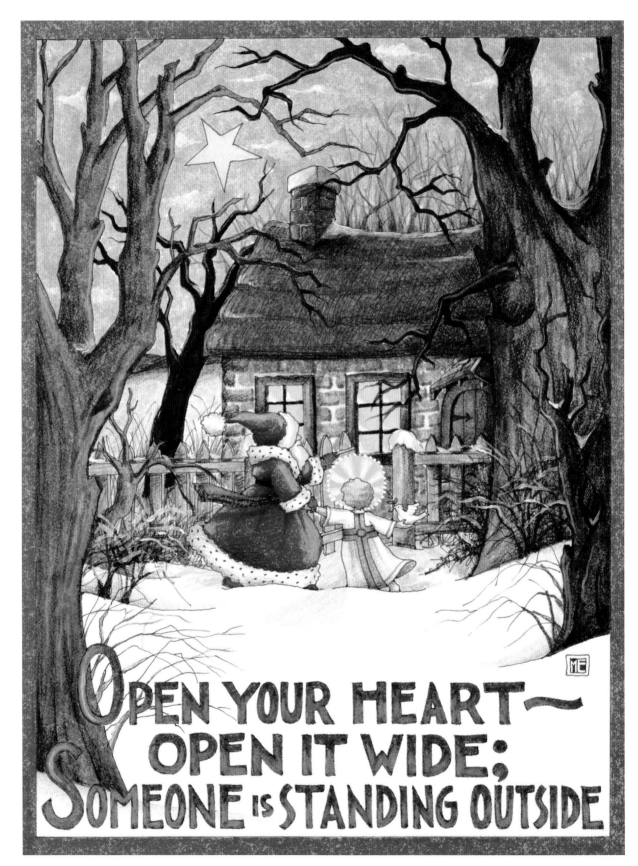

OPEN YOUR HEART~
OPEN IT WIDE;
SOMEONE IS STANDING OUTSIDE

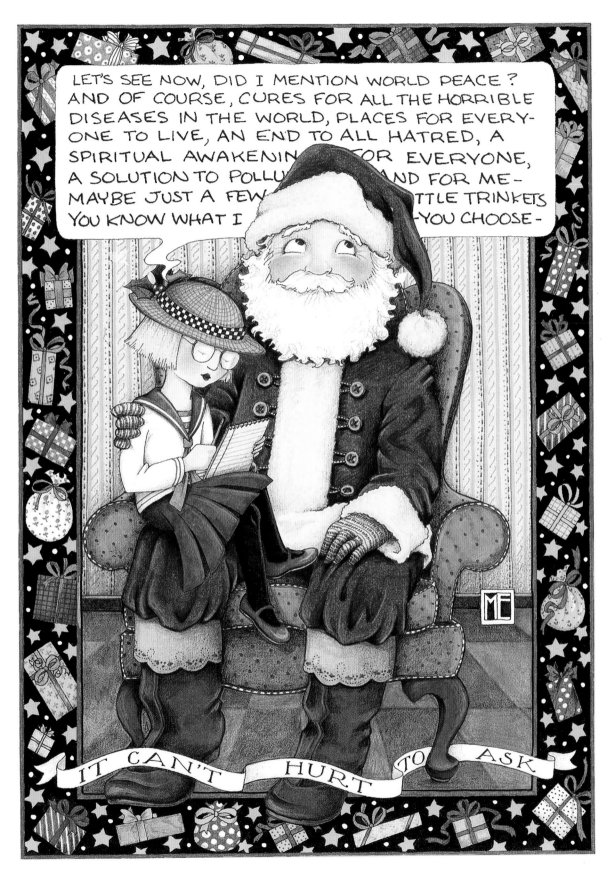

It Can't Hurt to Ask

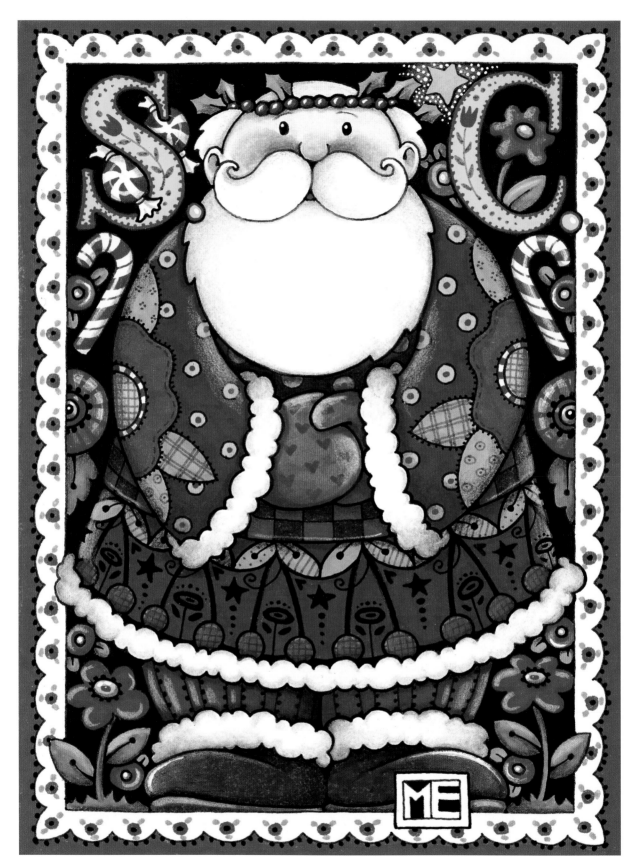

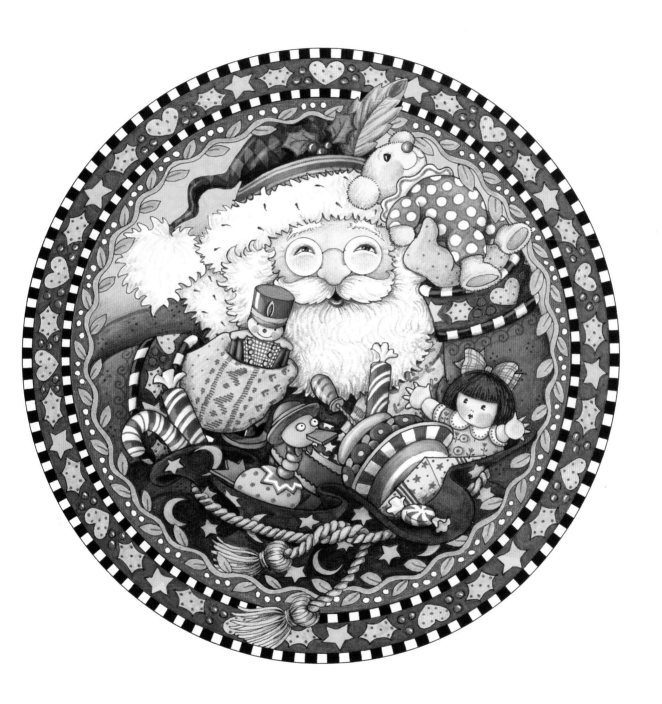

Santa With Toys

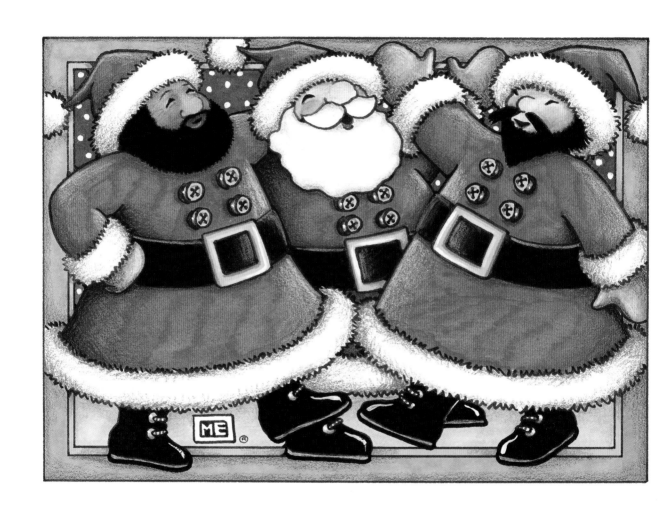

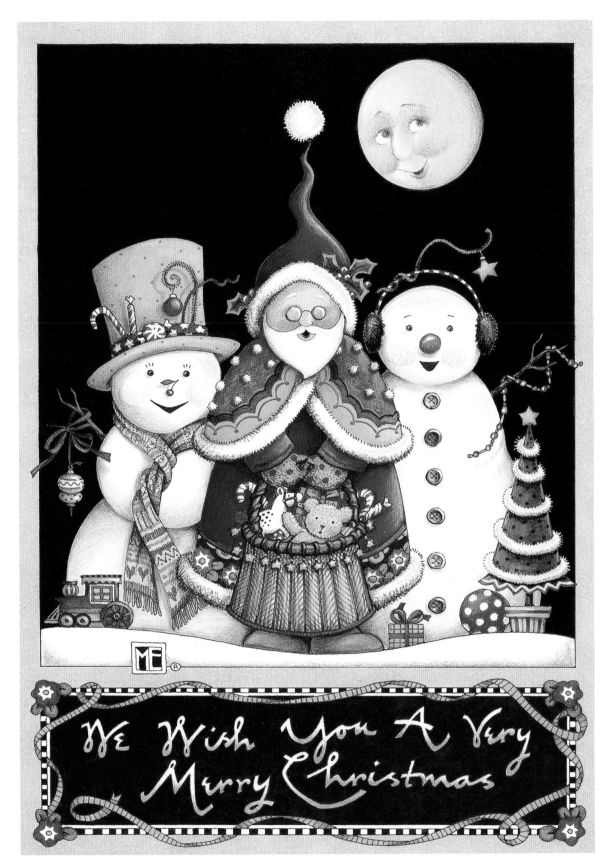

Santa and Snow Boys

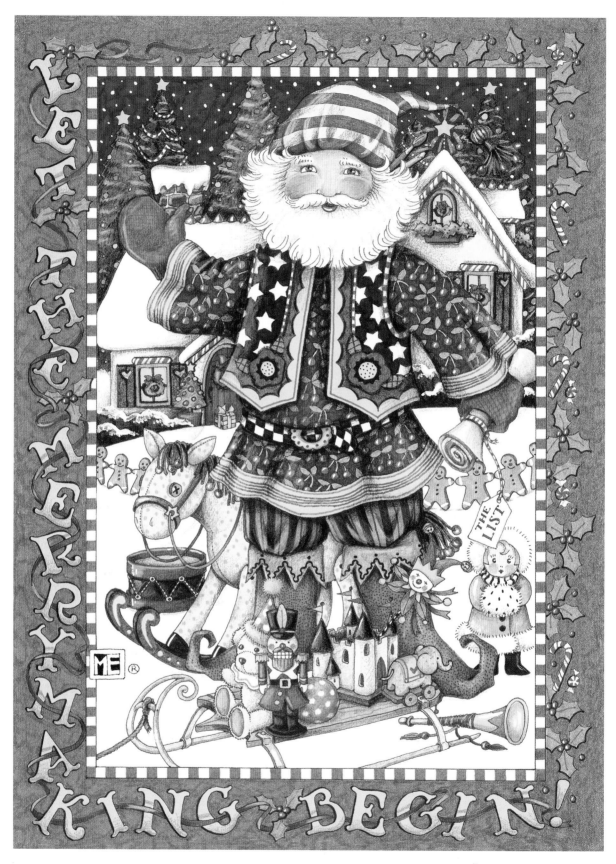

Let the Merrymaking Begin

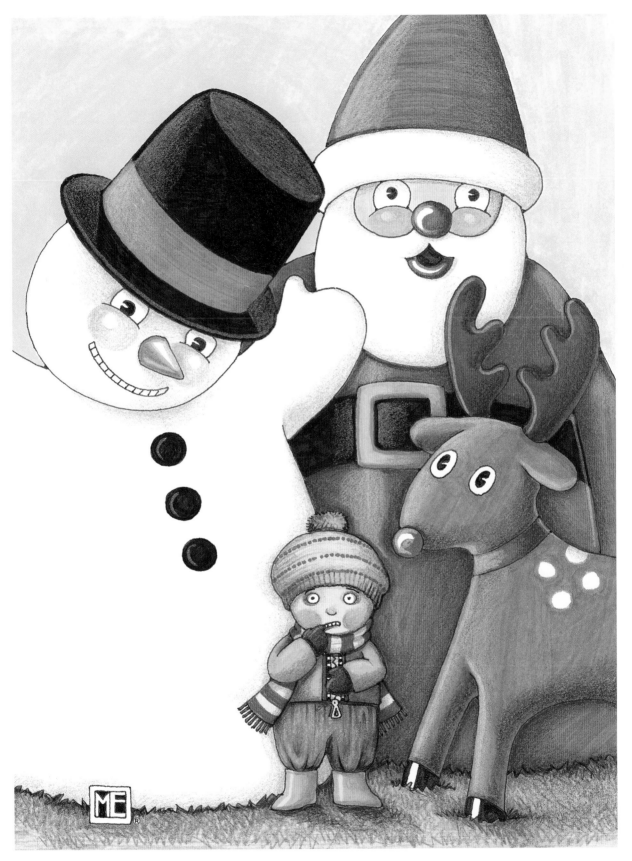

Christmas Blow Ups

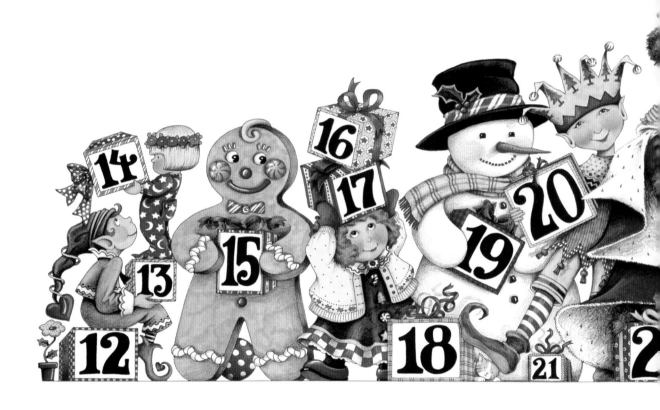

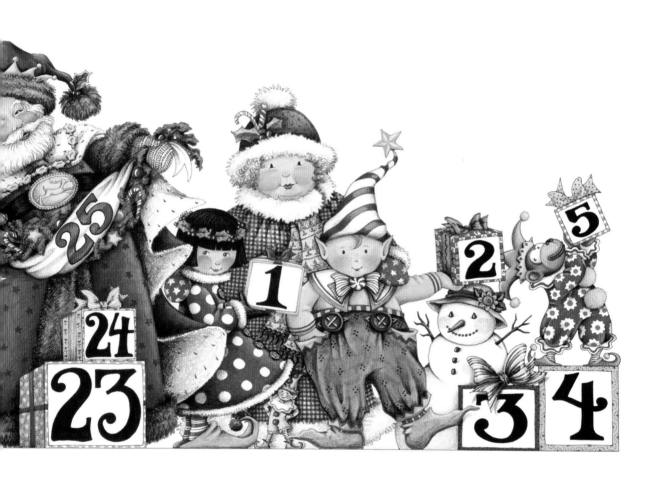

Countdown to Christmas

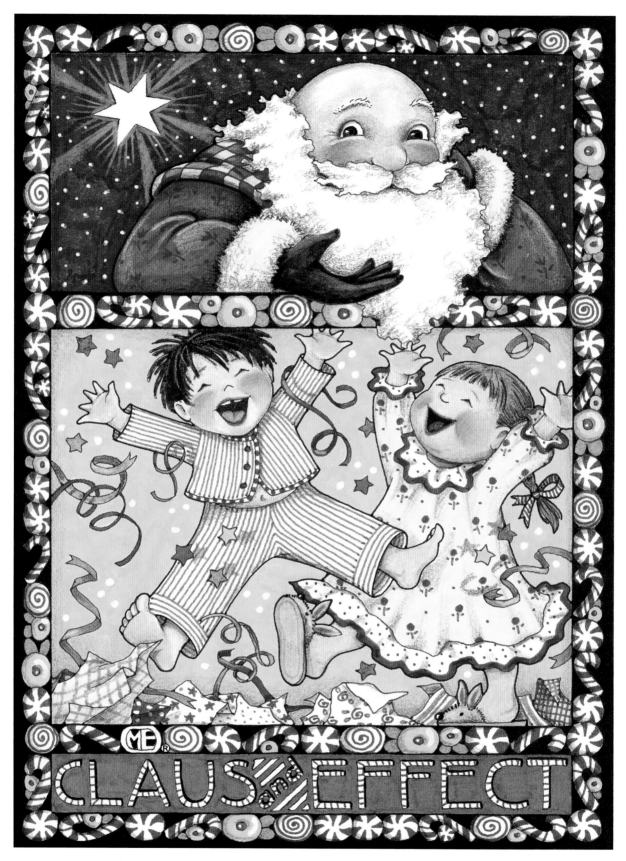

Claus and Effect

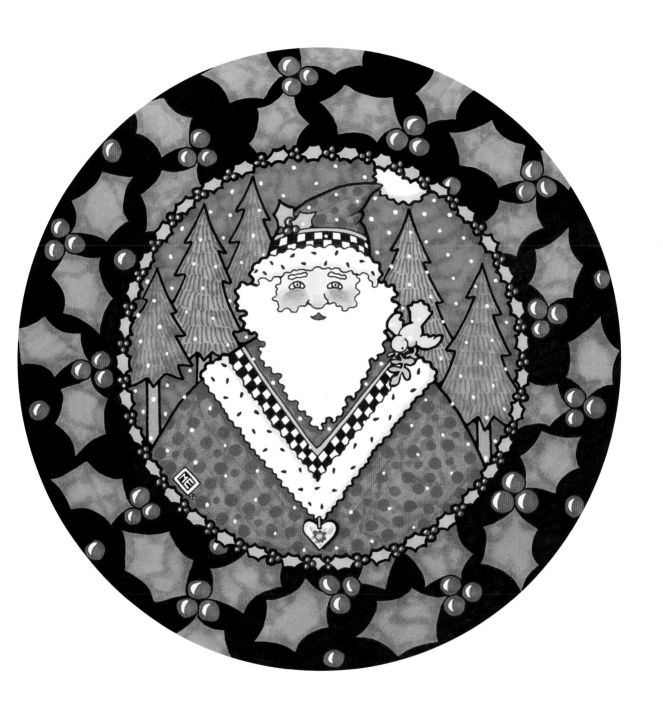

Santa and Holly

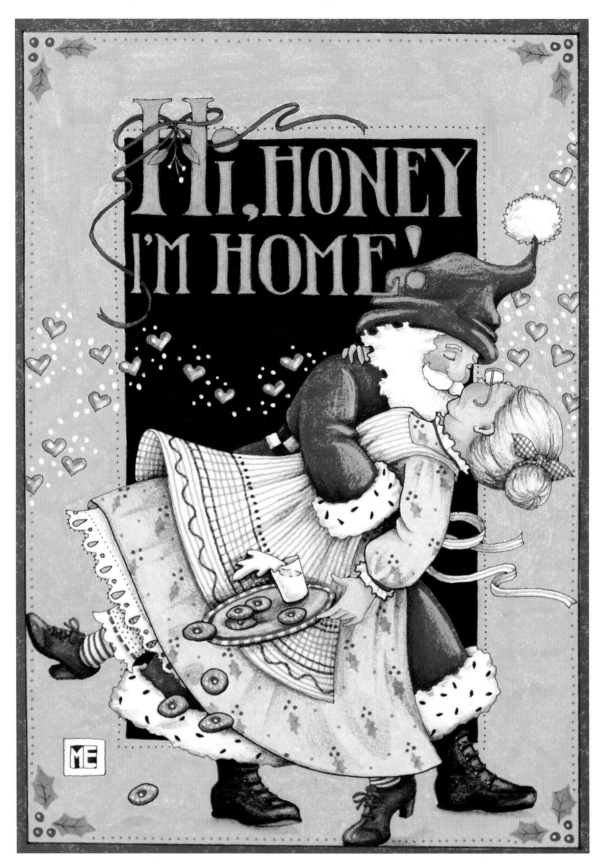

Hi, Honey, I'm Home

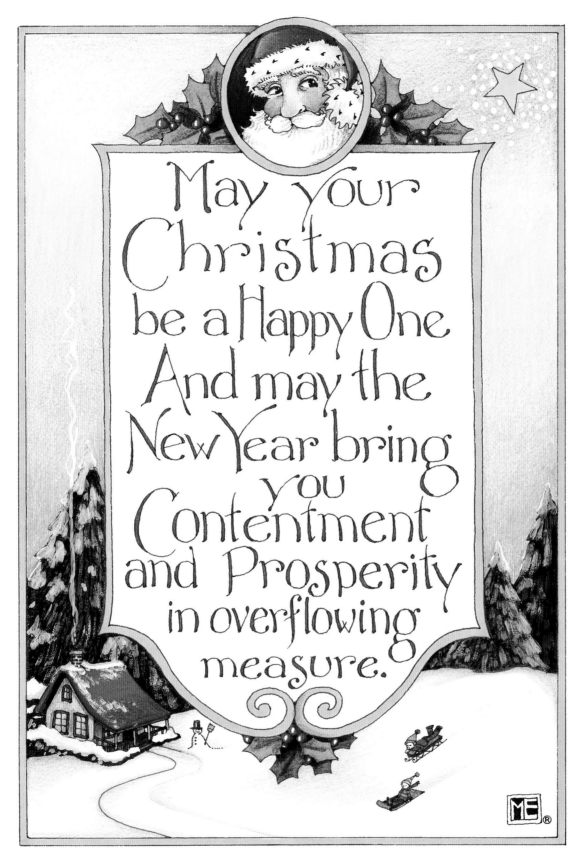

May Your
Christmas
be a Happy One
And may the
New Year bring
you
Contentment
and Prosperity
in overflowing
measure.

Christmas Sentiment

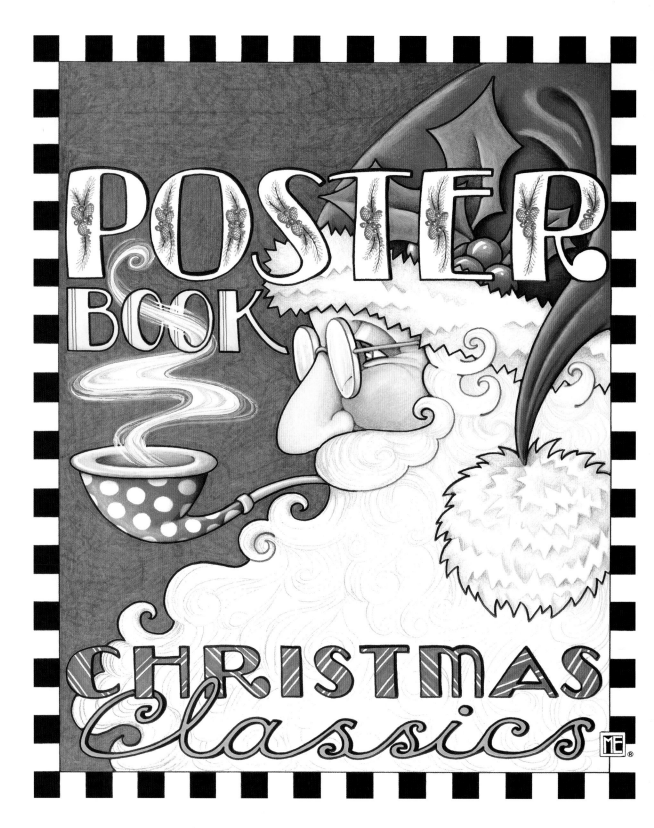

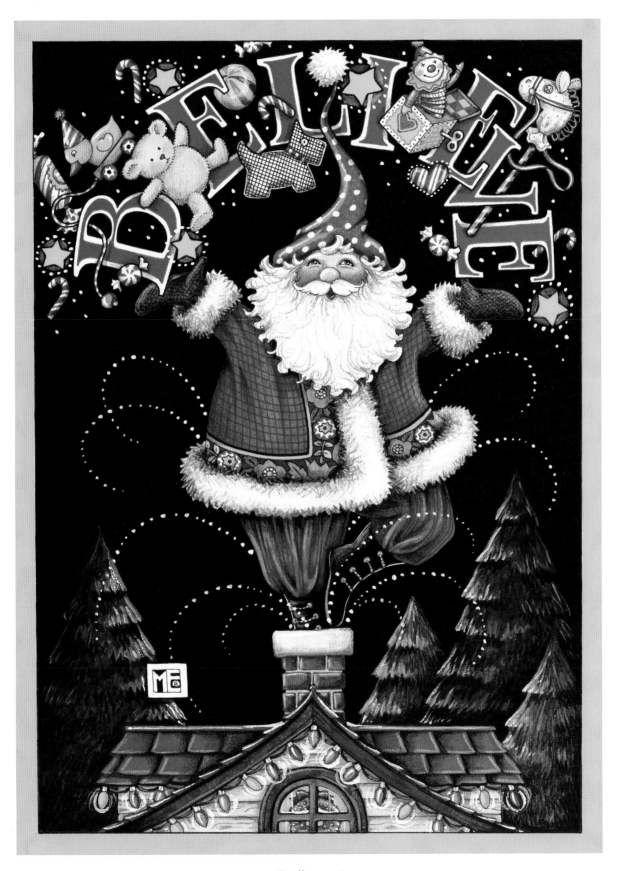

Believe II

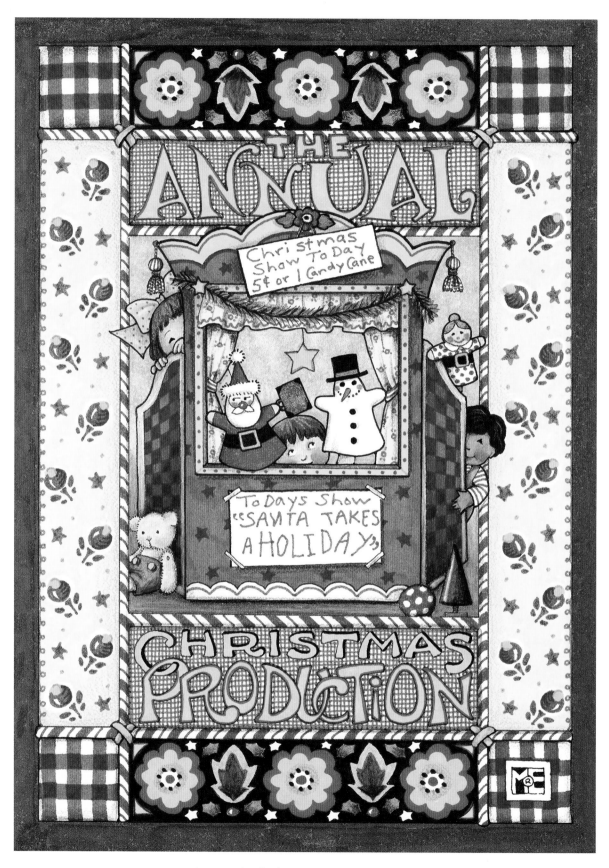

The Annual Christmas Production

Christmas Show Today 5¢ or 1 Candy Cane

Todays Show "SANTA TAKES A HOLIDAY"

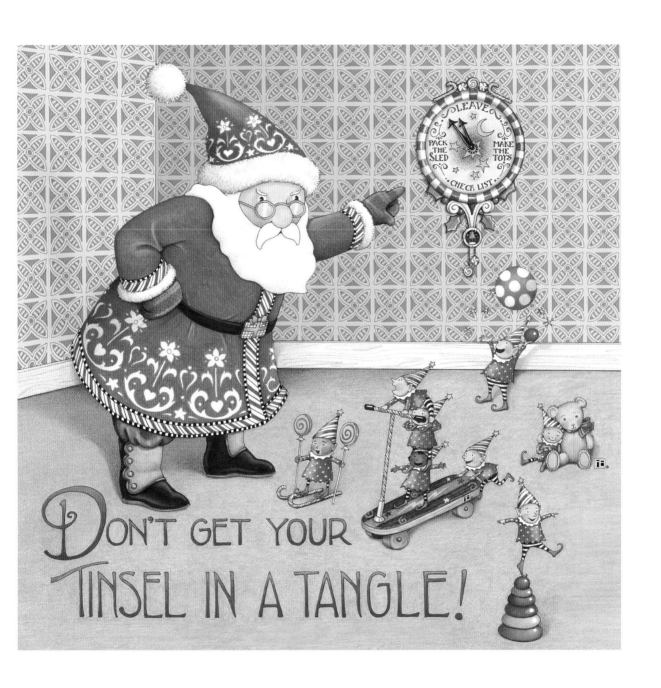

DON'T GET YOUR TINSEL IN A TANGLE!

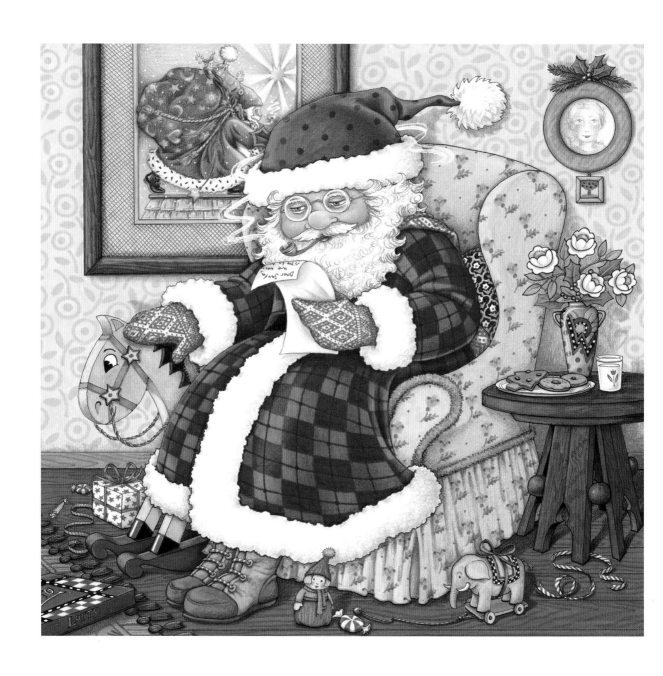

Santa Letter

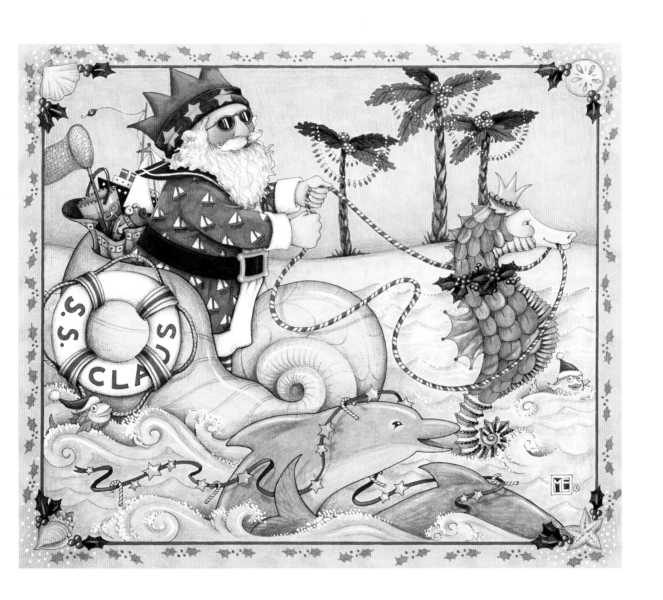

S.S. Claus

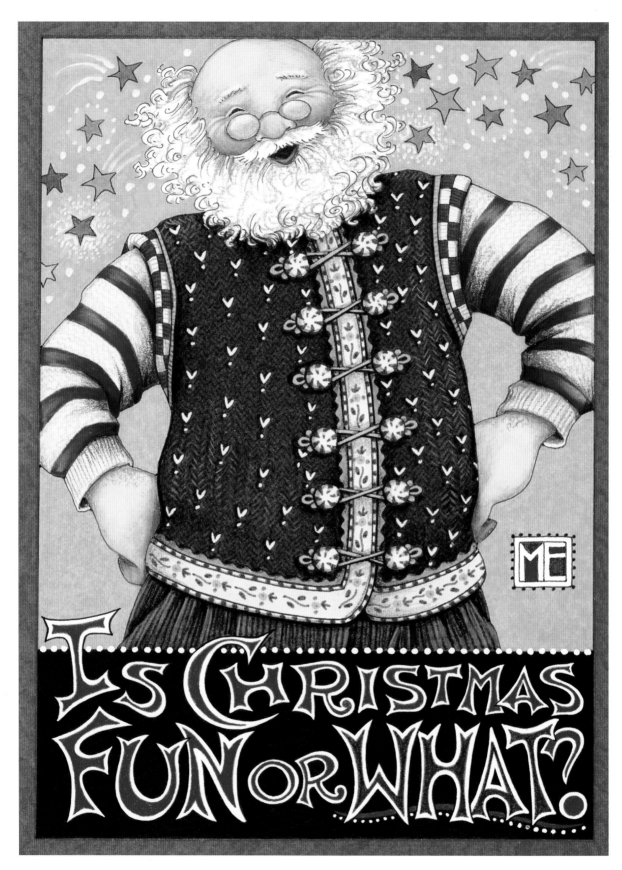

Is Christmas Fun or What?

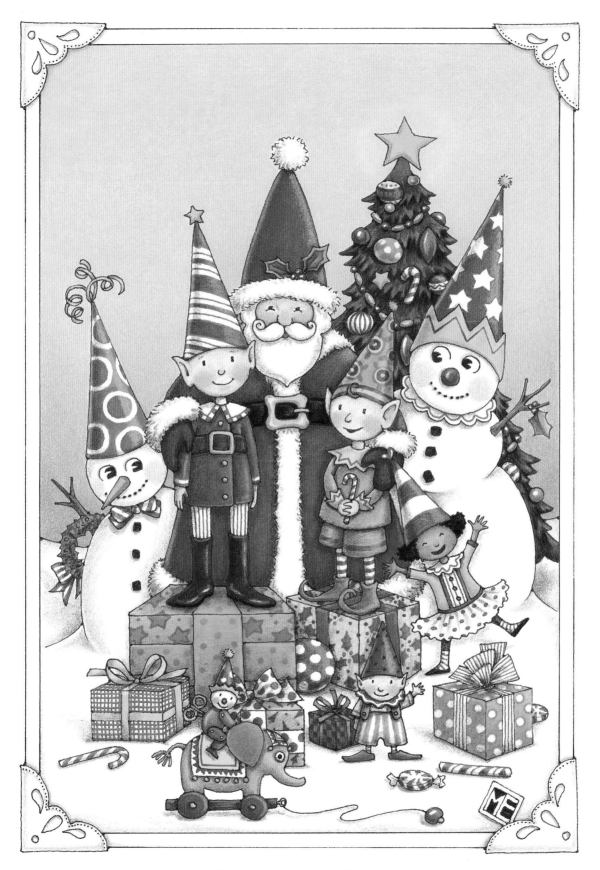

Santa and Elves Photo

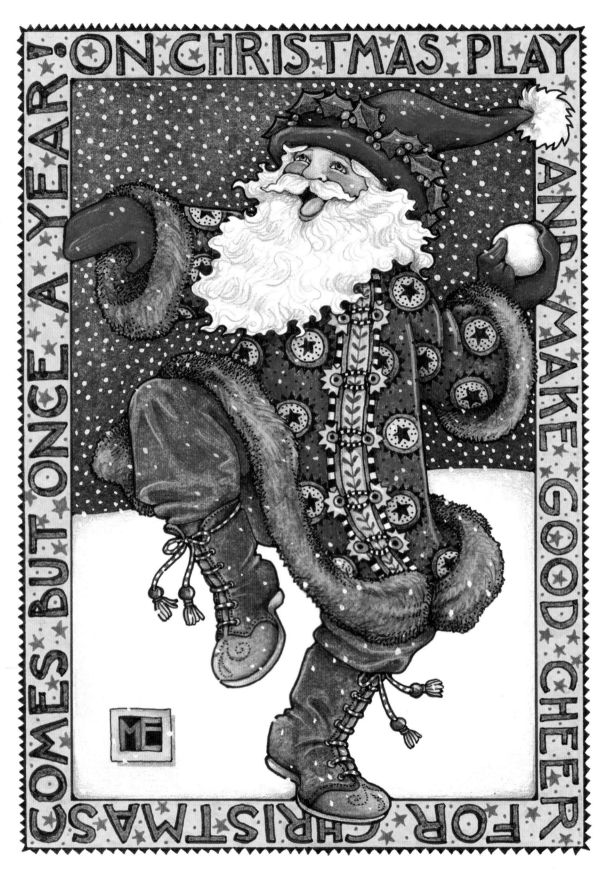

On Christmas Play

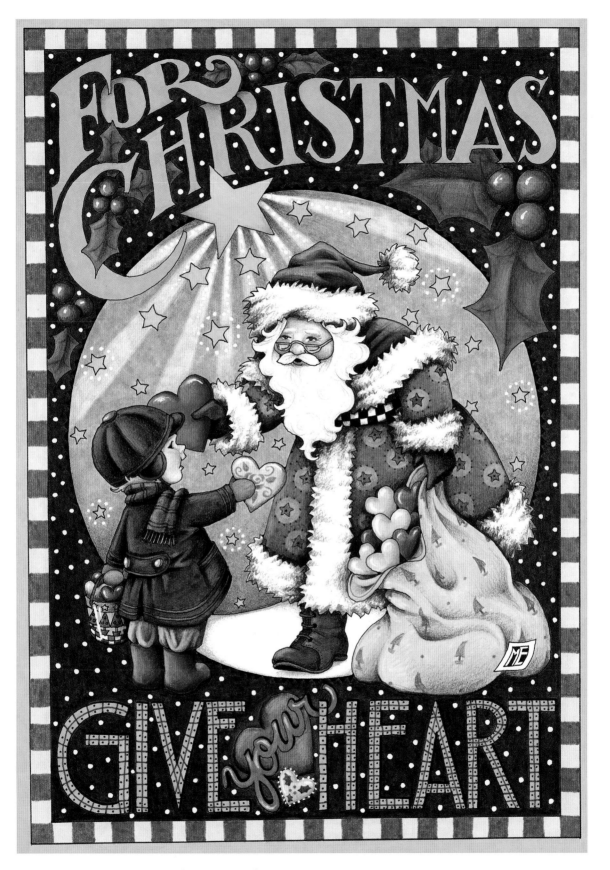

Give Your Heart

FROM ALL OF US

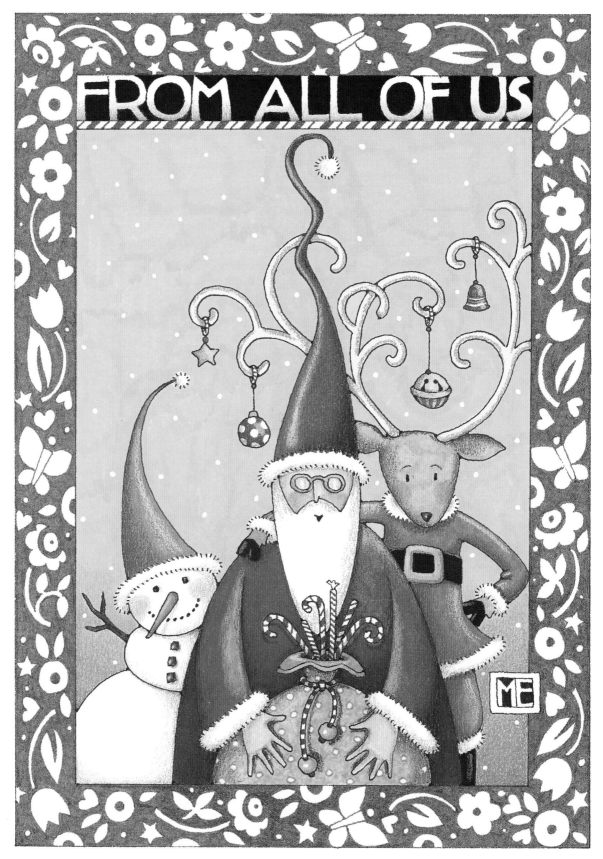

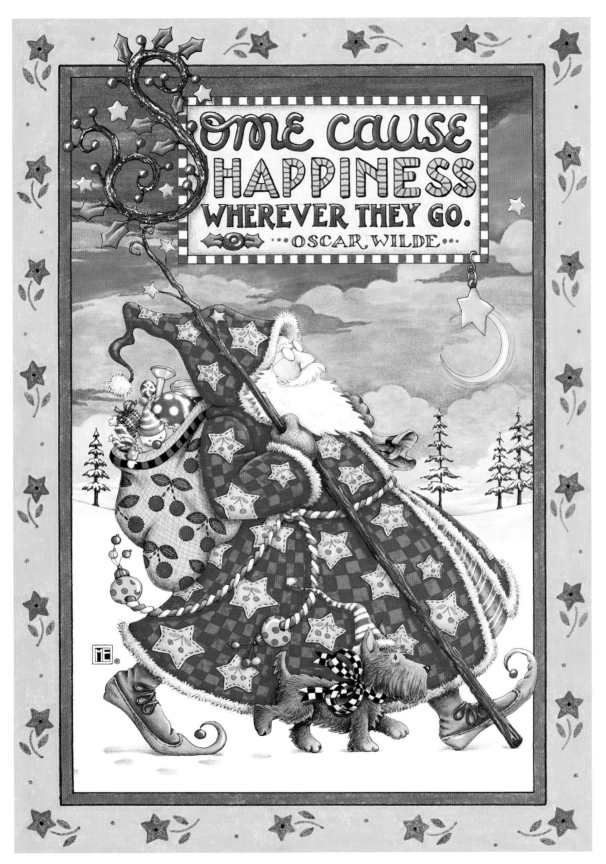

Some cause HAPPINESS wherever they go.
···OSCAR WILDE···

Check Cherry Santa

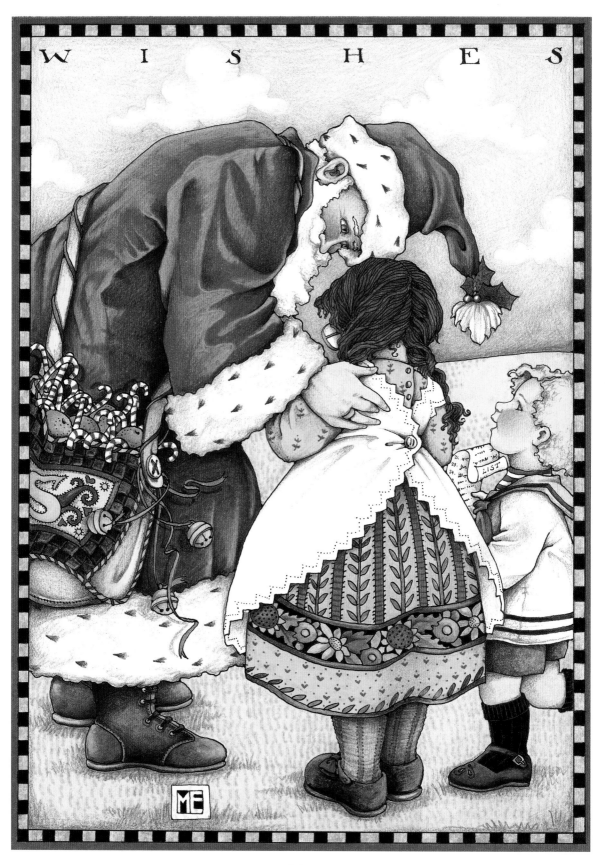

Wishes

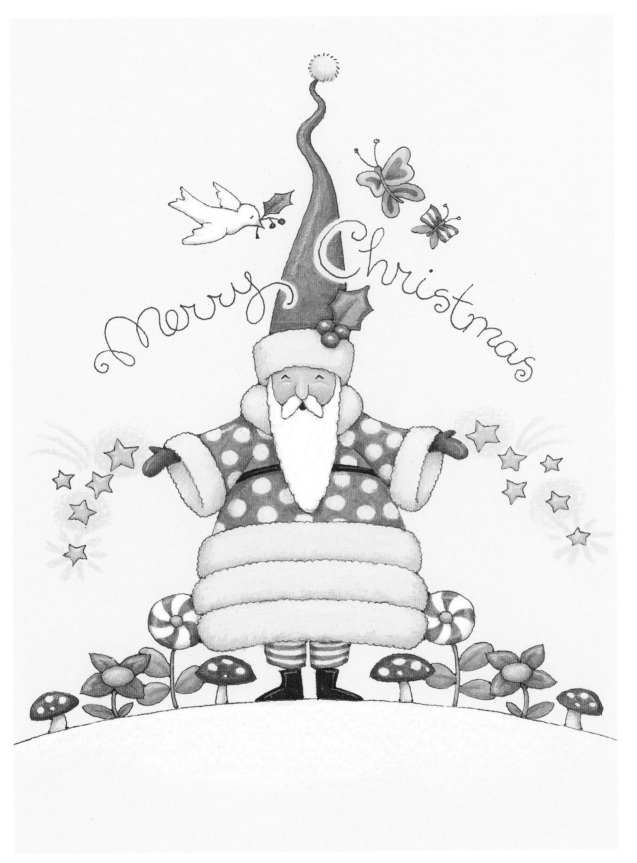

Merry Christmas

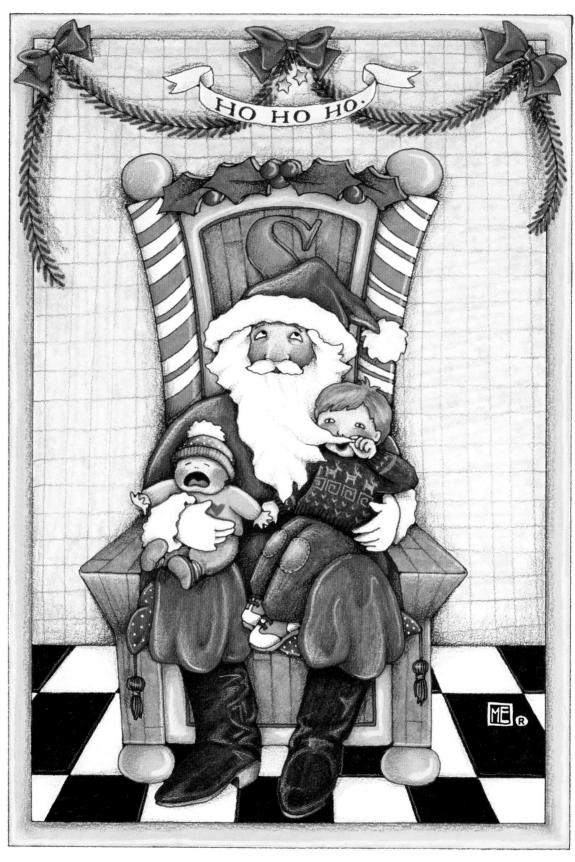

Ho Ho Ho

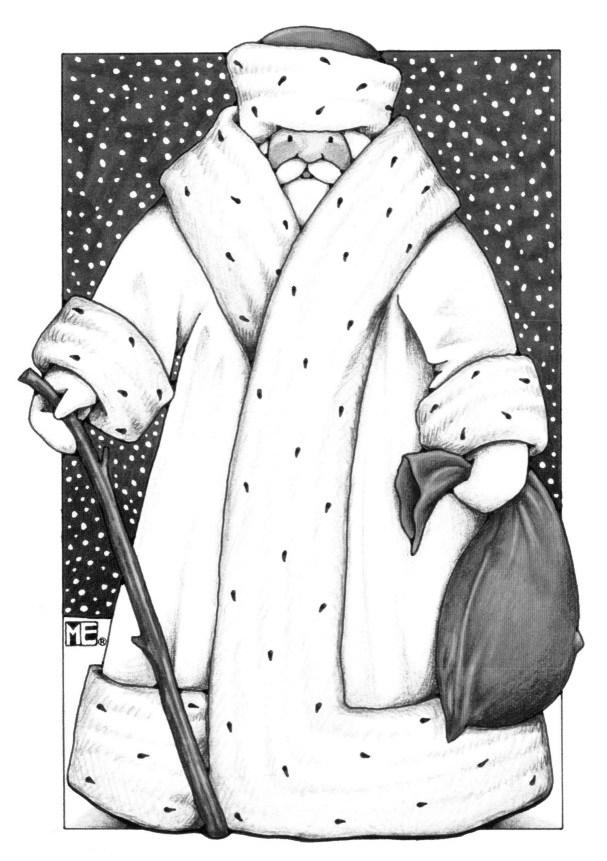

Father Christmas

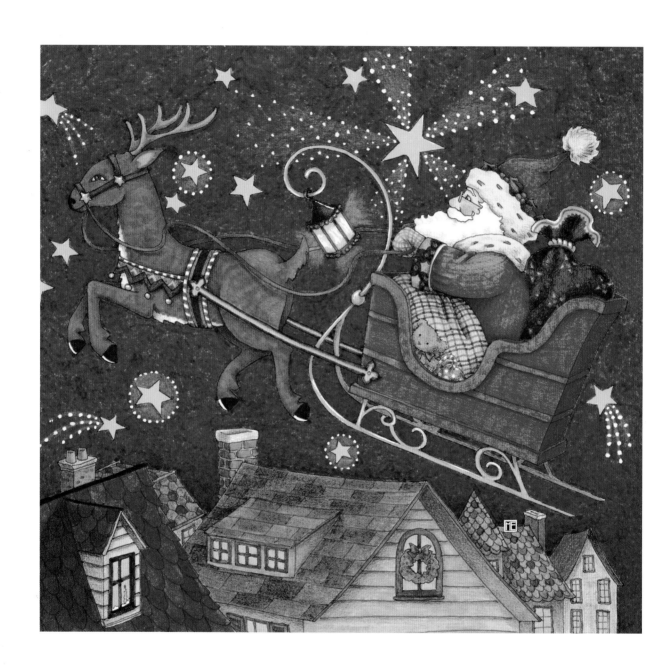

Santa Over the Rooftops

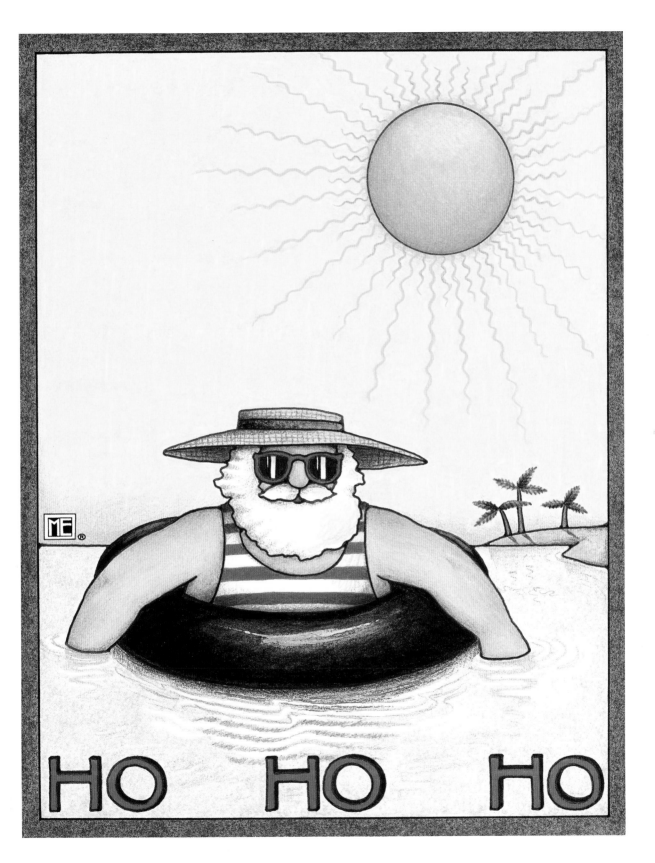

Sunburned Santa

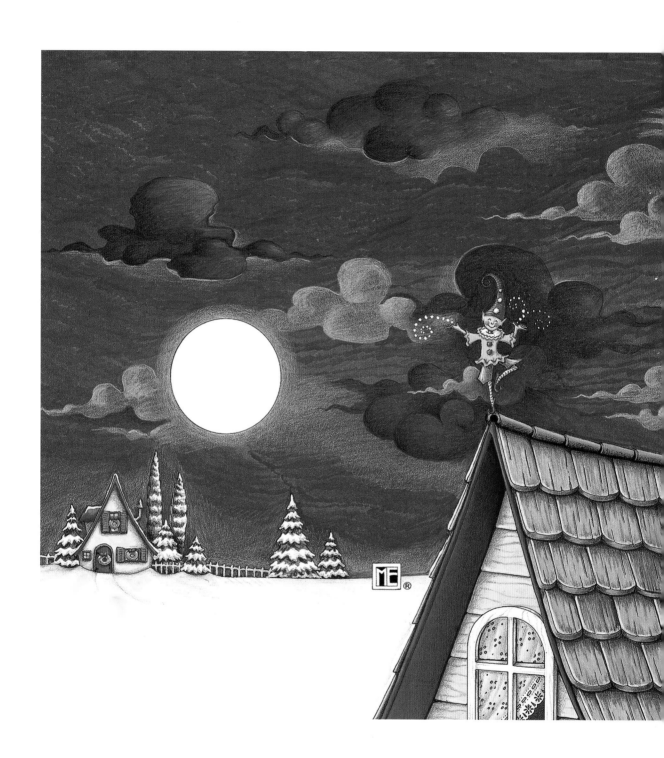

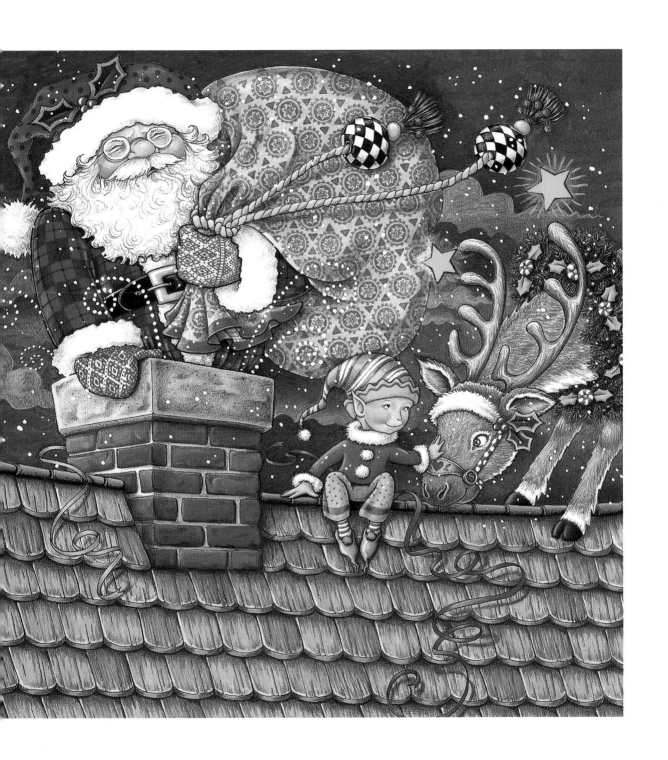

Chimney Squeeze

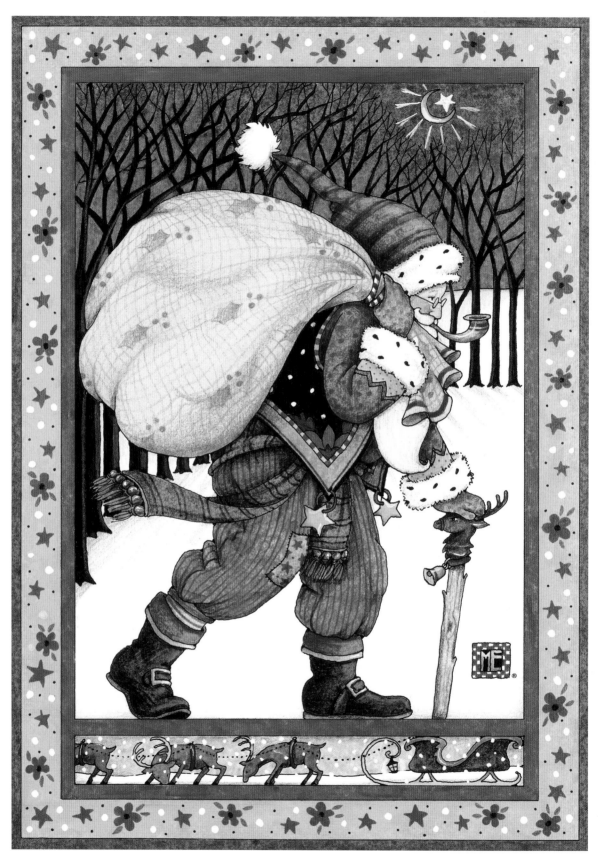

Christmas Is Coming

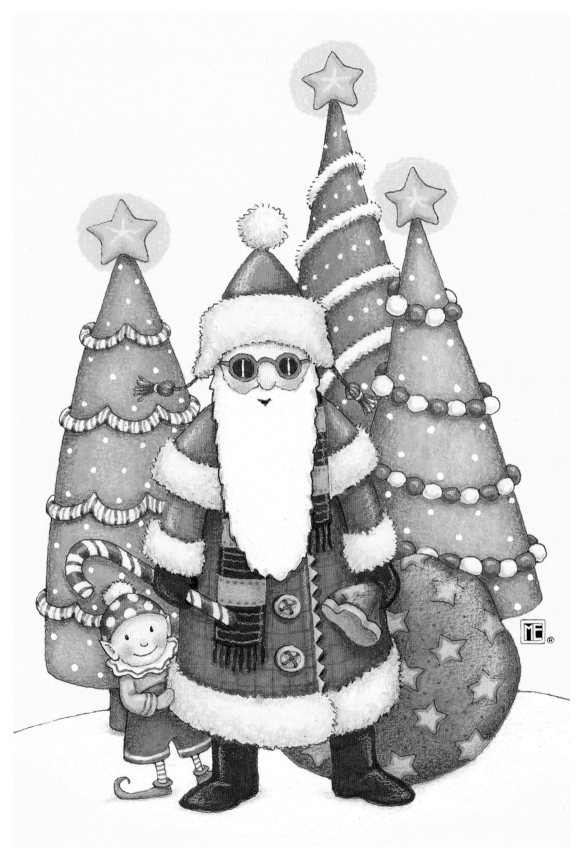

Bearded Breit Santa

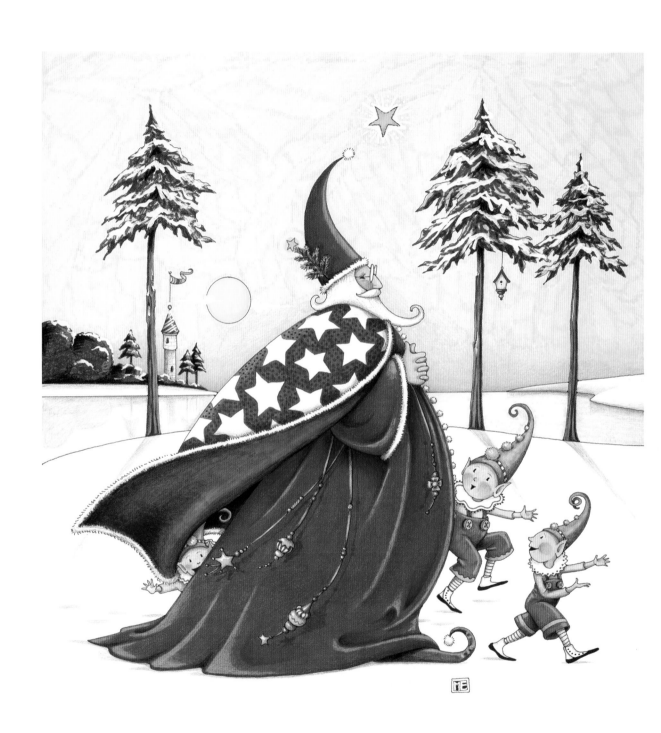

The Christmas Wizard

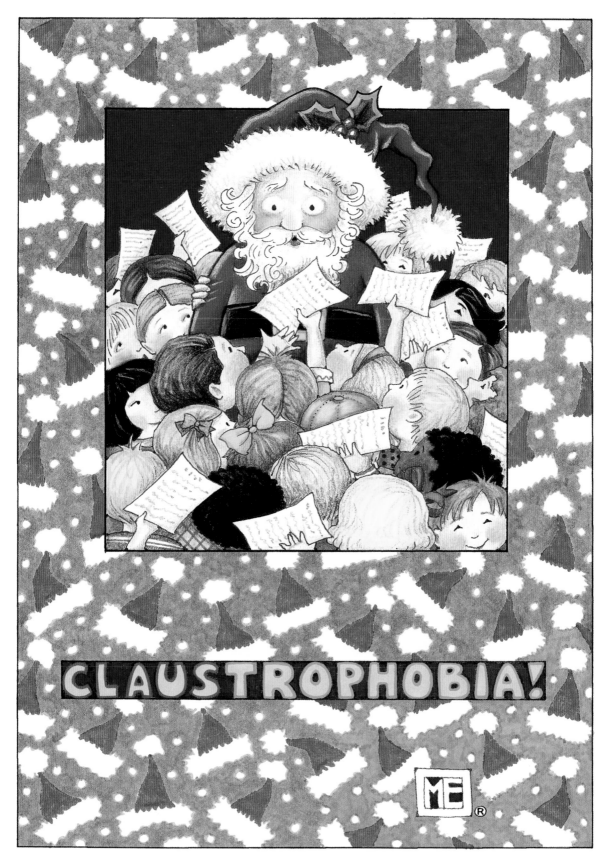

Claustrophobia

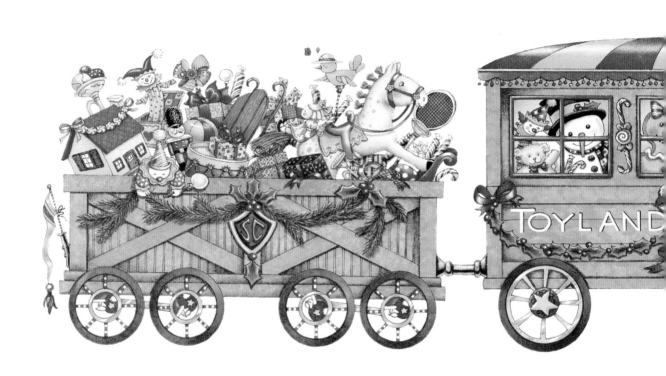

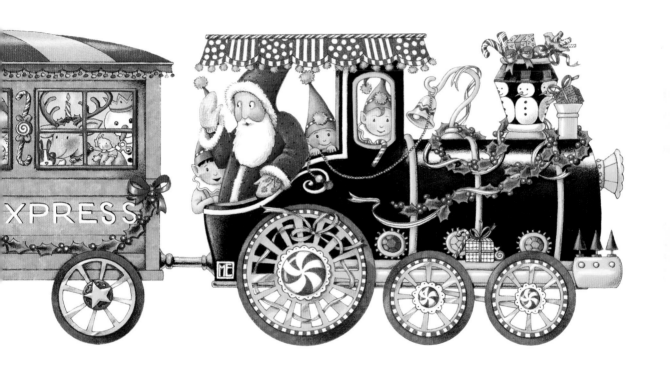

Toyland Express

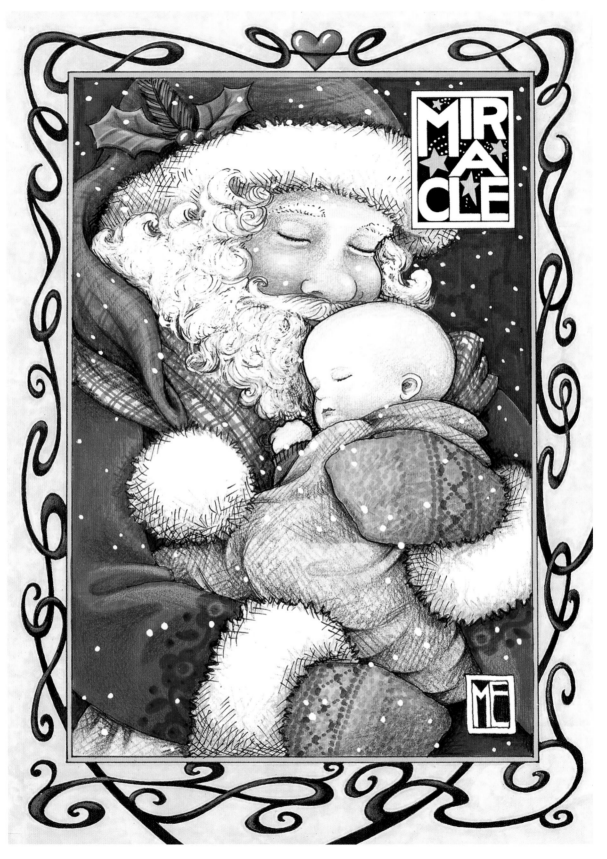

Santa Baby

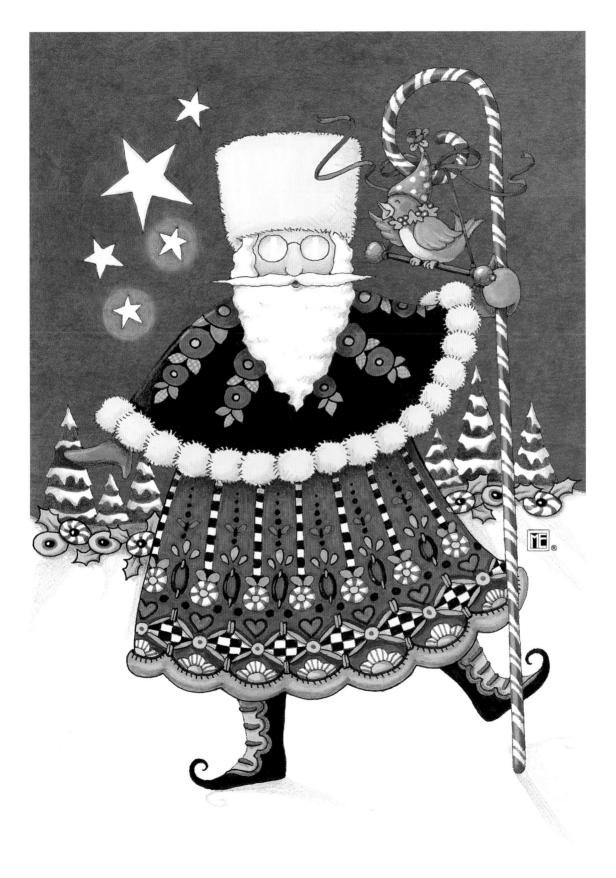

Russian Santa

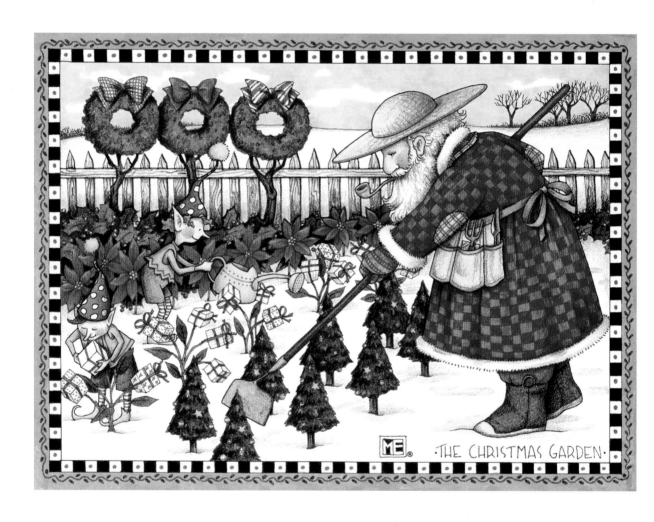

·THE CHRISTMAS GARDEN·

Santa's Garden

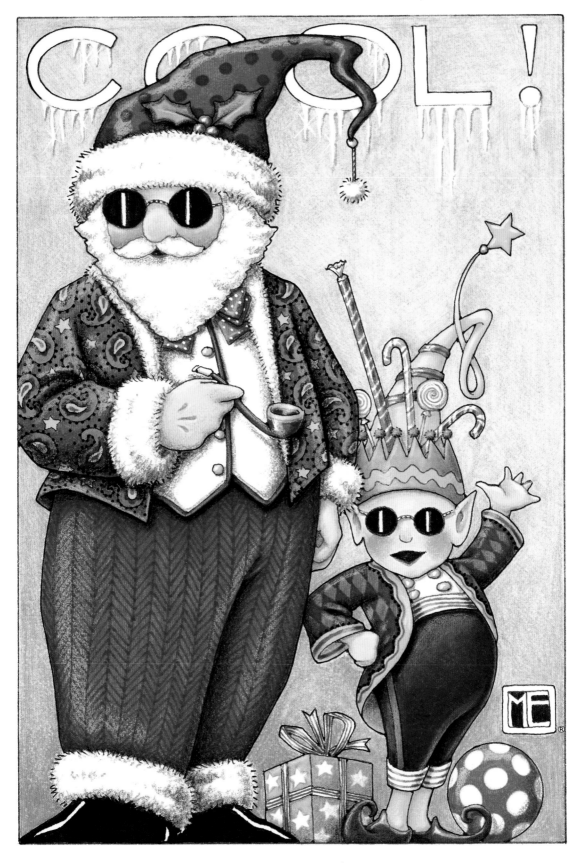

Christmas Dudes

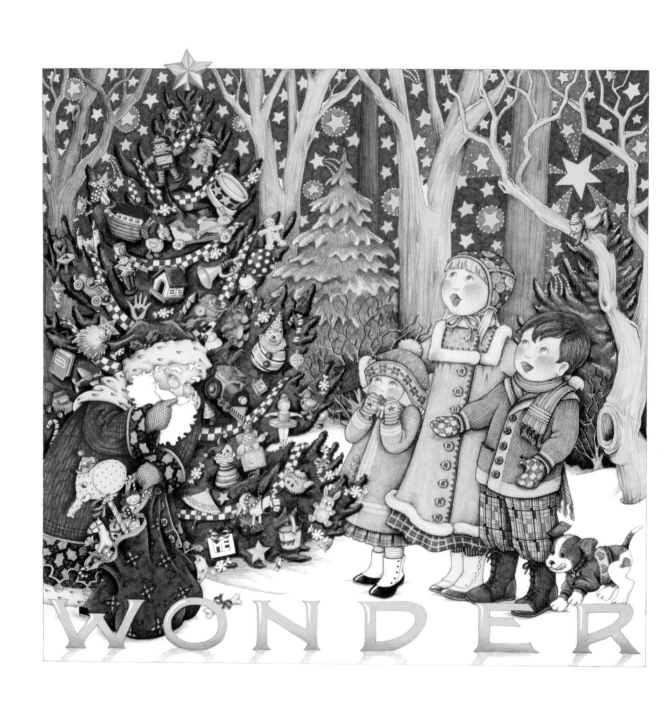

Wonder of Christmas

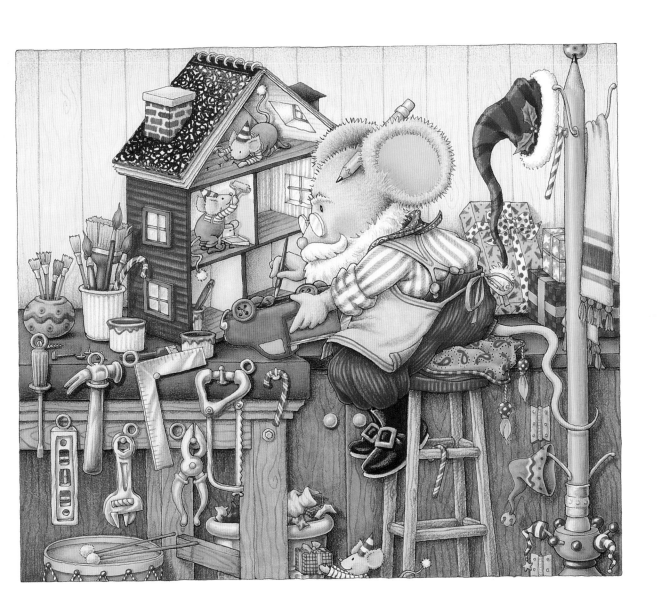

Santa Mouse Dollhouse

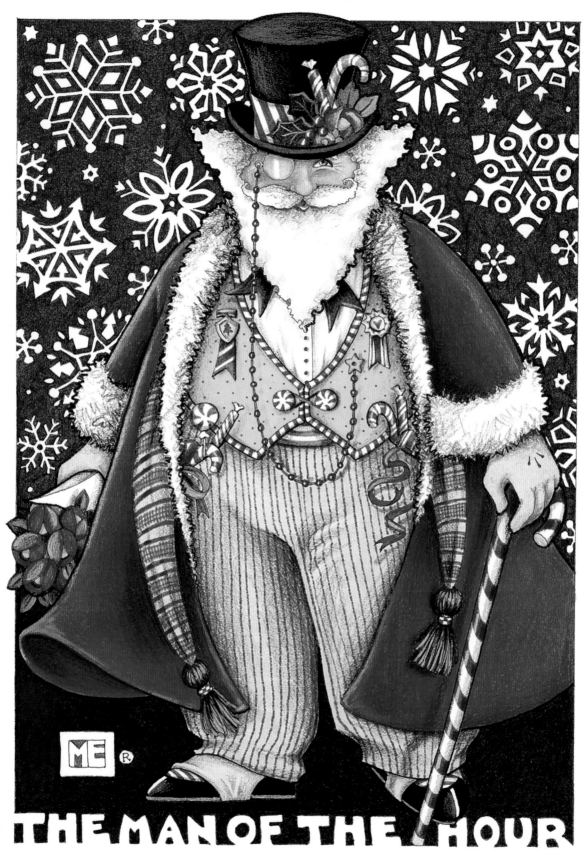

THE MAN OF THE HOUR

The Man of the Hour

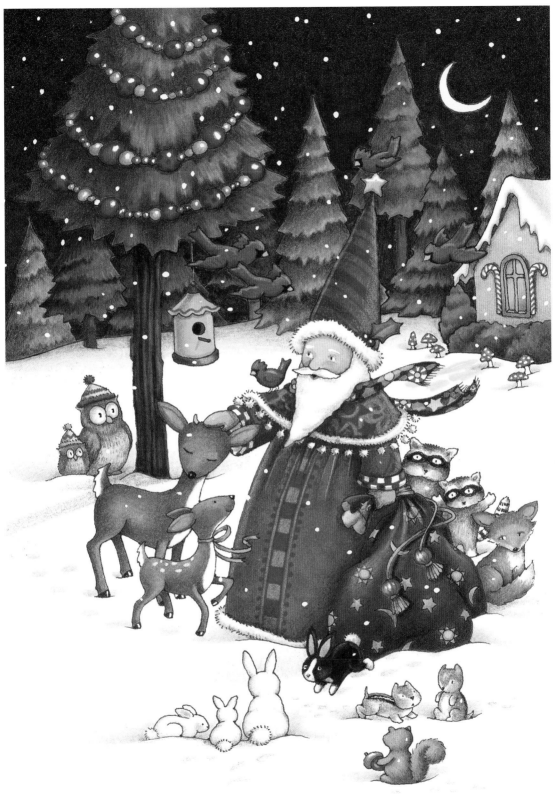

Santa's Gathering

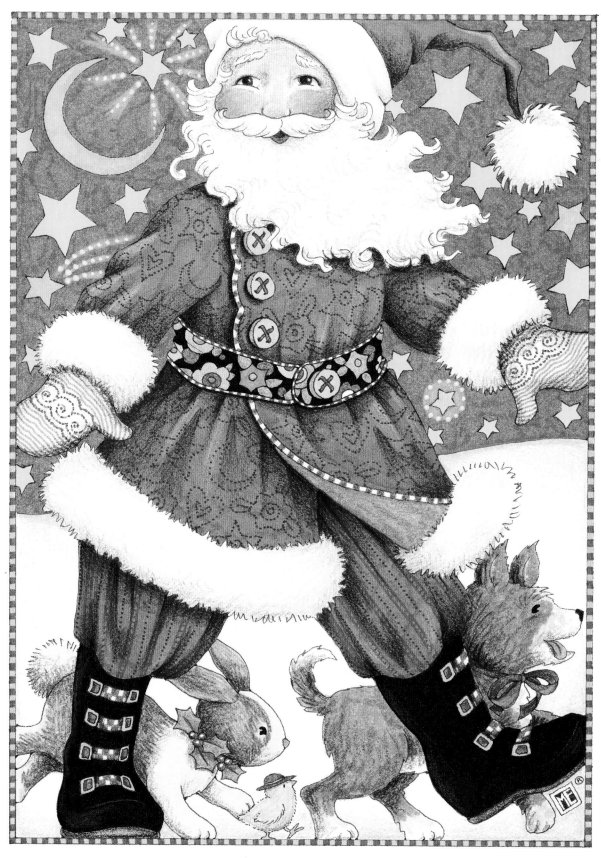

Starry Santa

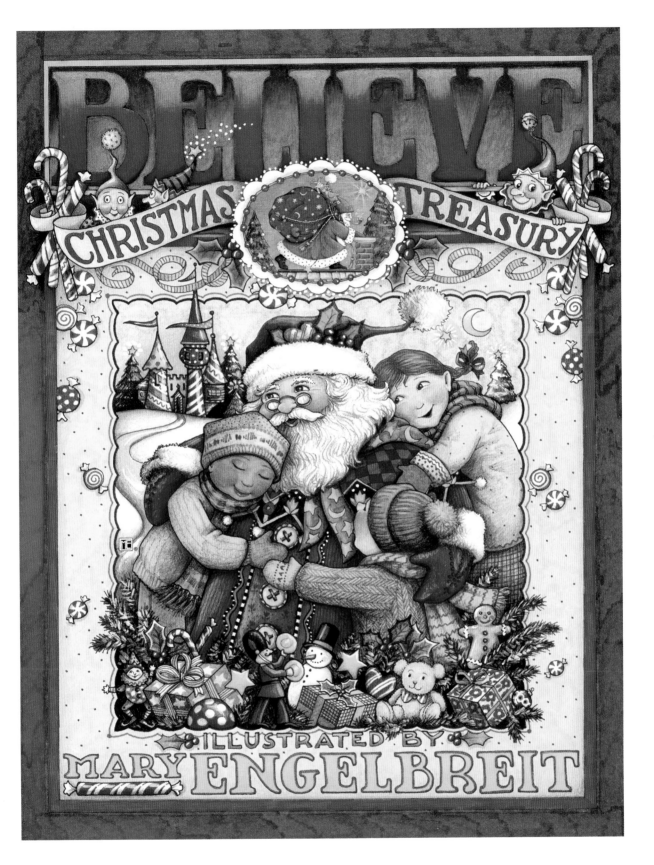

Christmas Treasury

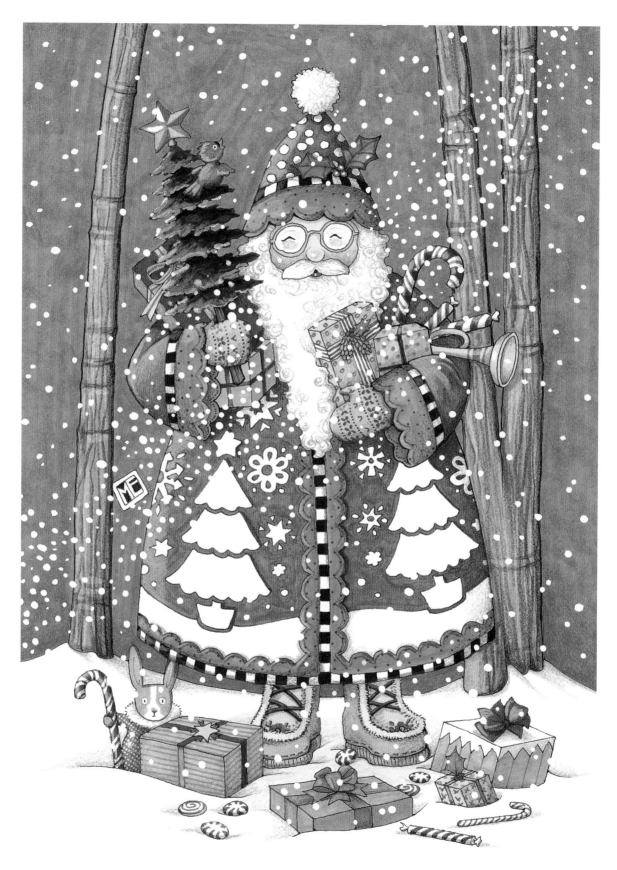

O Christmas Tree Santa

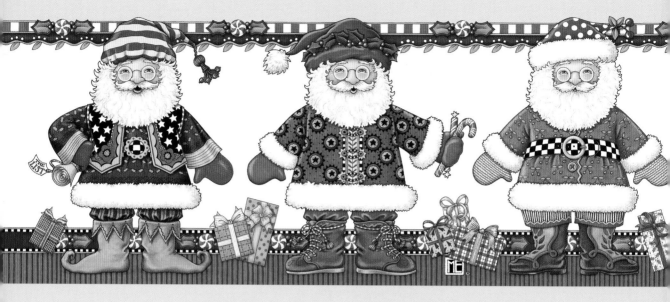

The BIG BOOK of SANTA

Andrews McMeel Publishing
a division of Andrews McMeel Universal
1130 Walnut Street, Kansas City, Missouri 64106

www.andrewsmcmeel.com

16 17 18 19 20 SDB 10 9 8 7 6 5 4 3 2 1

ISBN: 978-1-4494-8058-5

Library of Congress Control Number: 2016934553

ATTENTION: SCHOOLS AND BUSINESSES

Andrews McMeel books are available at quantity discounts with bulk
purchase for educational, business, or sales promotional use. For information,
please e-mail the Andrews McMeel Publishing Special Sales Department:
specialsales@amuniversal.com.